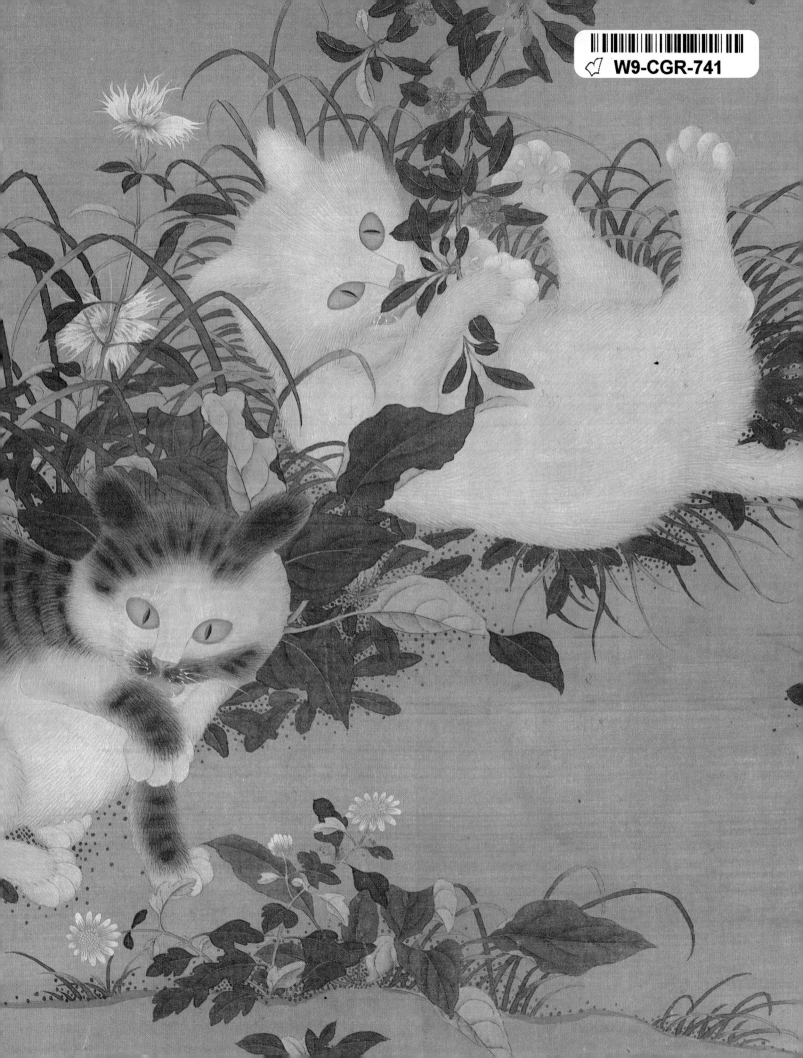

METROPOLITAN
CATS

THE FAVORITE CAT.

METROPOLITAN CATS

Text by
JOHN P. O'NEILL
Design by
ALVIN GROSSMAN

THE METROPOLITAN MUSEUM OF ART, NEW YORK
HARRY N. ABRAMS, INC., PUBLISHERS, NEW YORK

Published by The Metropolitan Museum
of Art, New York
Bradford D. Kelleher, Publisher
John P. O'Neill, Editor in Chief
Margot Feely, Project Supervisor
Rosanne Wasserman, Editor
Alvin Grossman, Designer

Copyright © 1981 by The Metropolitan
Museum of Art

Library of Congress Cataloging in Pub-
lication Data

Metropolitan Museum of Art (New
York, N.Y.)
 Metropolitan cats.

 1. Cats in art. 2. Metropolitan
Museum of Art (New York, N.Y.)
I. O'Neill, John Philip, 1931–
II. Title.
N7668.C3M4 1981 704.9'432 81-9590
ISBN 0-87099-276-7 (MMA) AACR2
ISBN 0-8109-1337-2 (HNA)

The photographs in this volume were
taken by Gene C. Herbert, Alexander
Mikhailovich, and Walter J. F. Yee, The
Photograph Studio, The Metropolitan
Museum of Art, with the exceptions of
those on pages 40–41 and 72, by Tim-
othy Husband; page 44, by Taylor &
Dull; pages 97 and 103, by Seth Joel;
and page 102, by Philip Dickinson.

Composition by York Typographers,
New York
Printed and bound by Dai Nippon
Printing Co., Ltd., Tokyo, Japan

FRONT AND BACK ENDPAPERS. **Spring
Play in a T'ang Garden.** Details of silk
hand scroll, 18th century, in the style
of Hsüan-tsung (Chinese, 1398–1435).
See description, p. 14

HALF TITLE AND FRONTISPIECE. **The
Favorite Cat.** Lithograph, by Nathaniel
Currier, publisher, American, 1834–
1857. The frontispiece is a detail.

OPPOSITE. **Pet Cat.** Painting on silk, by
Kawabata Gyokusho (Japanese, 1842–
1913)

OVERLEAF. **Poster Calendar Cover.** Color
lithograph poster (1897), by Edward
Penfield (American 1866–1925)

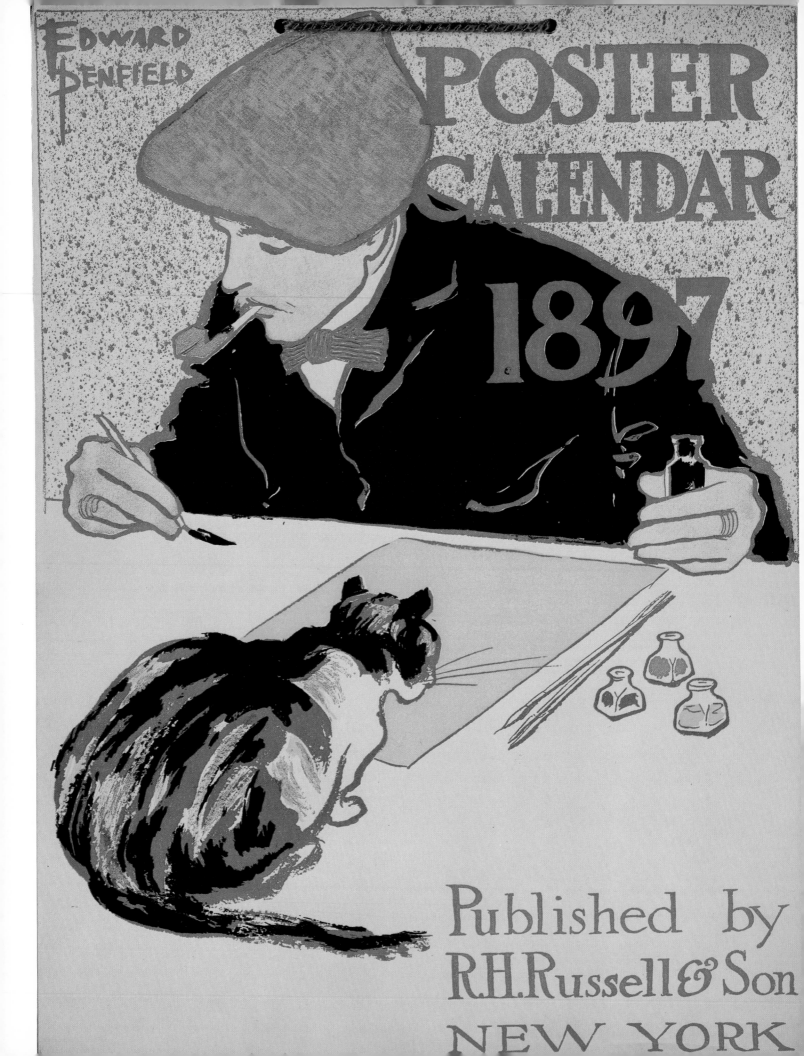

Introduction

Cats, cats, and more cats appear in the works of art that form the collections of The Metropolitan Museum of Art. They figure in oil paintings by both the great masters and naïve artists, and in prints, sculptures, drawings, ceramics, and textiles. A selection of these representations of felines has been gathered together in *Metropolitan Cats.*

Cats familiar and fantastic, drawn from many periods and cultures, throng these pages. Mischievous kittens from Chinese hand scrolls and from American lithographs jostle ancient and sacred Egyptian cats sculptured in bronze or painted on the walls of tombs. Cats from medieval manuscripts, Renaissance paintings, Japanese prints, and modern canvases join cats that figure in fairy tales and fables and cats that shared artists' lives.

Cats have inspired love, reverence, fear, and hatred out of all proportion to their interest—or lack of interest—in the human race. *Felis catus* or *felis domestica,* the domestic cat, has held its enormous appeal for the more than five thousand years since prehistoric peoples first tamed it and trained it to hunt, to fish, and to guard grain stores. In the evolution of civilization in the Nile Valley, cats came to be worshipped. The Egyptians named the cat *mau,* meaning "to see," gave cats shrines of their own, and allowed them to enter the sacred precincts of temples. Phoenician sailors probably carried cats from Egypt, where their exportation was forbidden, to other Mediterranean lands.

Domestic cats were brought to England when it was a Roman colony, and from England they entered Ireland. Saint Patrick had a cat, who perhaps helped him to rid the isle of snakes, since cats are one of the few animals that will attack and kill snakes. By medieval times, cats had become scarce and valuable in many European countries, despite the superstitious belief that they were the familiars of witches. In the Renaissance, cats found such great favor that some artists included them in paintings of the Holy Family. By the eighteenth century, cats figured prominently both in the ornate paintings that decorated palaces and in the didactic engravings of illustrated books; they were modeled in aristocratic porcelain and in homely earthenware; their doings were celebrated in prose and their deaths were mourned by poets.

From the nineteenth century to modern times, cats have been favorite subjects for artists throughout the world. With the new methods of publishing images, pictures of cats were lithographed and circulated to every parlor. With the new ways of seeing that artists discovered, European and American cats borrowed aspects of the Japanese, or lent the energy of their forms to abstract line and mass. While the behavior and spirit of the cats themselves are consistent in every time and place, the eye of each artist and the demands of different traditions and mediums create an entertaining variety of ways to participate in the fun of watching cats.

I would like to thank Shari Lewis, formerly of the Museum's Editorial Department, who conceived this volume; Margot Feely, whose knowledge, taste, and perseverance were invaluable; Claudia Funke and Nancy Pivnick, who were able and astute researchers; and Rosanne Wasserman, who skillfully smoothed a frequently awkward text. Many of the entries are based on the previously published research of the Museum's curators, past and present, and I owe all of them a deep debt of gratitude for my borrowings. Any mistakes I have introduced, however, are on my own head, and I apologize for them.

John P. O'Neill

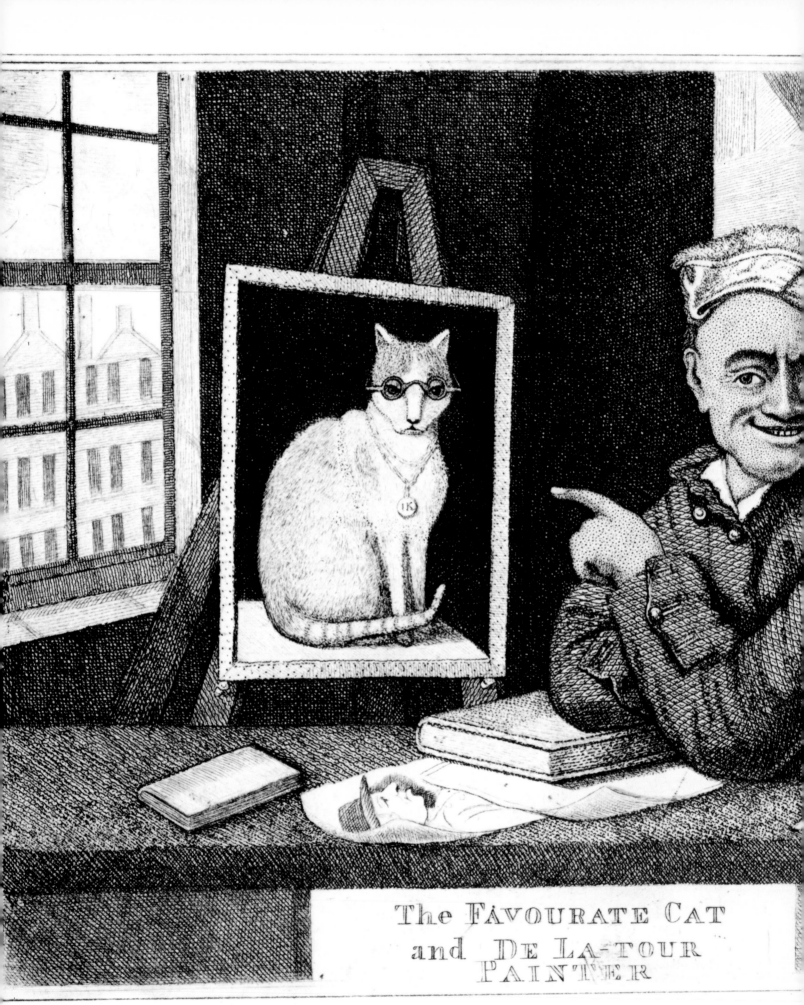

The FAVOURATE CAT
and DE LA-TOUR
PAINTER

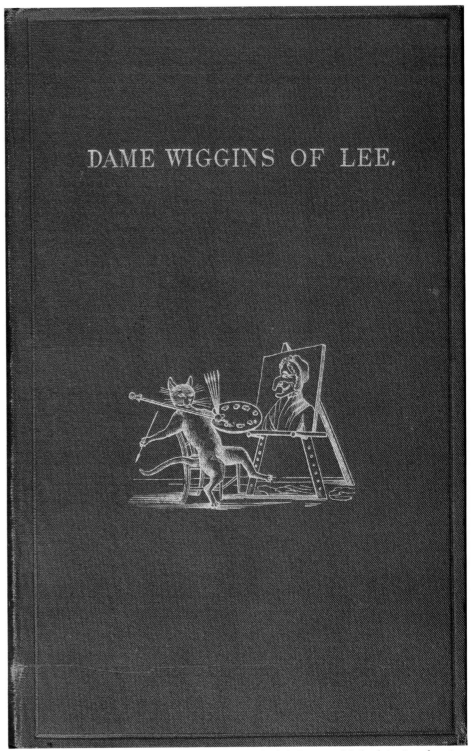

DAME WIGGINS OF LEE.

Dame Wiggins of Lee and Her Seven Wonderful Cats, published in London in 1823, is subtitled *A Humorous Tale. Written Principally by a Lady of Ninety.* On the cover, Dame Wiggins's portrait is painted by one of her industrious cats— a situation exactly opposite to that of La Tour and cat. The cats were multitalented, as page 6 of the first edition shows: "The Dame was quite pleas'd,/And ran out to market;/When she came back/They were mending the carpet./The needle each handled/As brisk as a bee;/'Well done, my good cats,'/Said Dame Wiggins of Lee."

The Favourate Cat and De La-tour, Painter. John Kay (Scottish, 1742–1826), a miniaturist and caricaturist, made more than nine hundred portraits, of which this is one of the most enigmatic. An 1813 etching with aquatint, it purports to represent the pastelist Maurice Quentin de La Tour (French, 1704–1788). But is the bespectacled cat, wearing the initials IK (for "Iohannes Kay"), a caricature of John Kay's cat (see p. 52) or of Kay himself?

Cat. The cat in this etching was skillfully created from a pure, almost discontinuous line. The artist, Mary F. Sargent (American, 1875–1963), has placed the figure in three-dimensional space by using cross-hatching in the upper left-hand corner.

L'Hiver: Chat sur un Coussin. No artist has been more passionately fond of cats than Théophile-Alexandre Steinlen (1859–1923), a French graphic artist who lived in Paris. He drew cats throughout his long career with unvarying grace and skill, particularly those of the Butte de Montmartre district of Paris. Steinlen's models were habitués of rooftops, gutters, cemeteries, and garbage bins, and were kept by the artists, seamstresses, and concierges of the Butte de Montmartre. Steinlen created cats in all colors and in shades of gray and white. In addition to making thousands of drawings, he modeled some images of cats in wax and cast others in bronze. The enormous yellow-eyed tiger cat here, luxuriously at rest on a pouf of crimson, regards all viewers with a sphinxlike glare. Steinlen has signed his name and added his monogram of three initials intertwined.

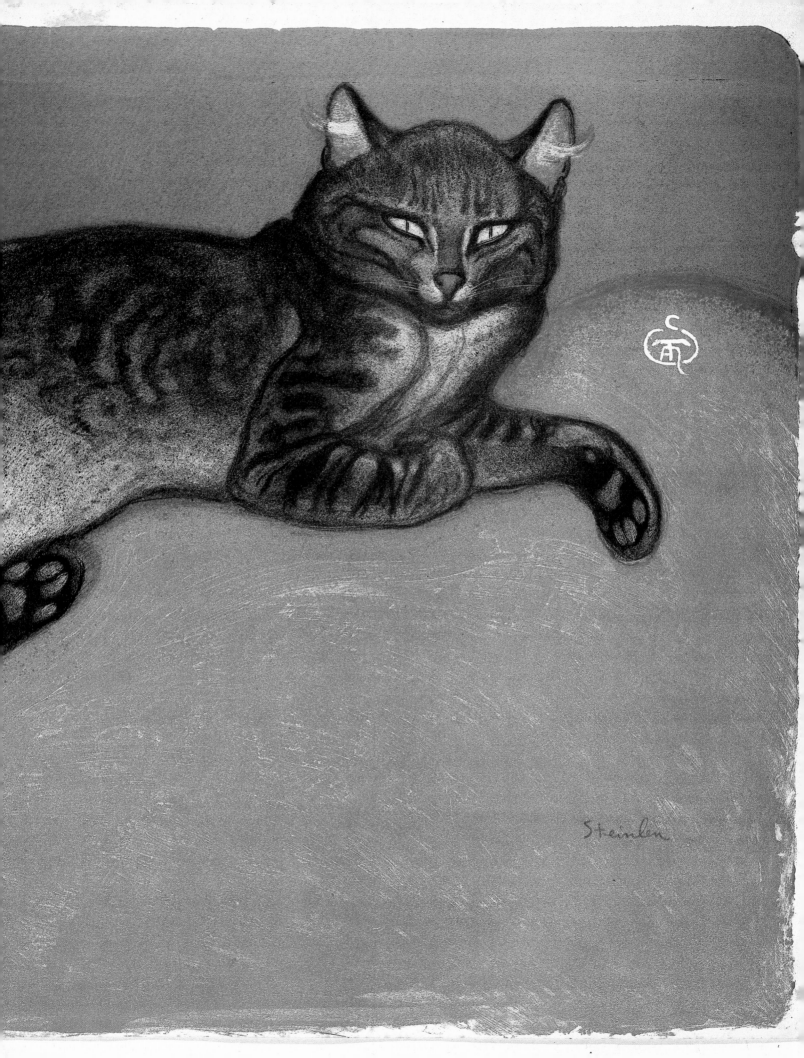

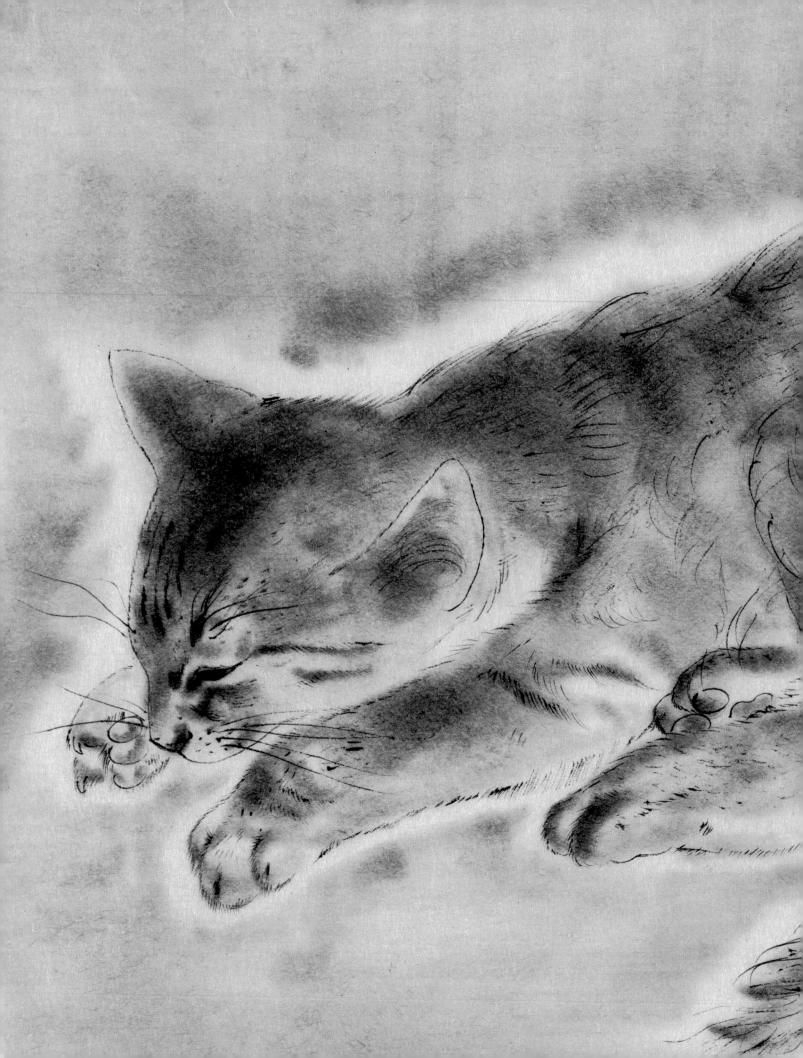

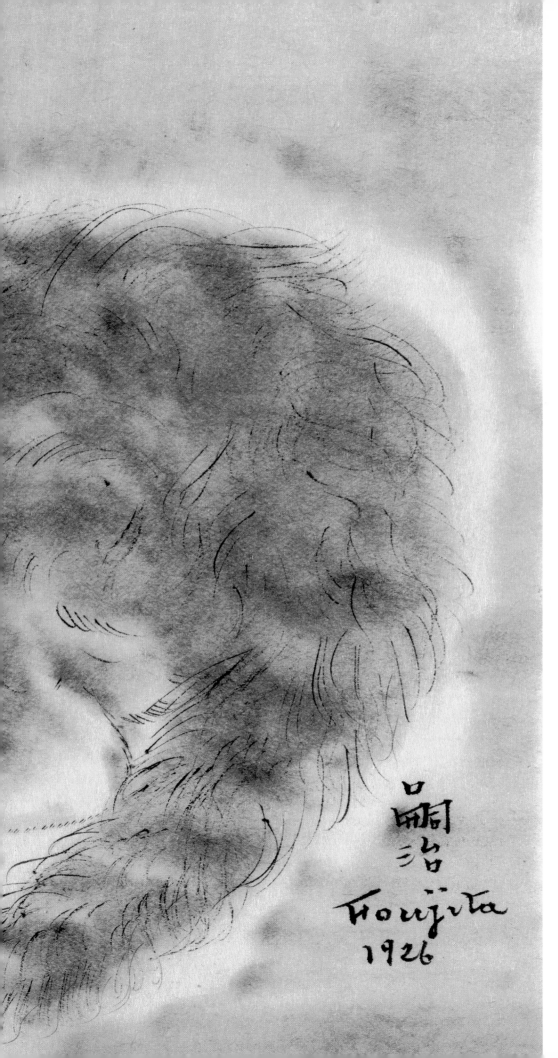

Petit Chat. Tsugouharu Foujita (1886–1968) was born in Japan, but spent most of his adult life in France, where he was nationalized in 1955. He achieved an international reputation for his paintings, drawings, and watercolors of cats, in which he adapted Japanese brushwork and linear images, using mainly black with some light colors.

Freely drawn in pen and black ink with gray washes, *Petit Chat* was signed in 1926. The Japanese characters above the artist's signature at the lower right give his first name.

Snoozing and relaxed, this cat seems to enjoy the best of all possible cat worlds, bringing to mind a quotation from the "Epistle to Bathhurst" by Alexander Pope:

> But thousands die, without or
> this or that,
> Die, and endow a College, or
> a Cat.

Doesn't this feline portrait truly epitomize the endowed cat?

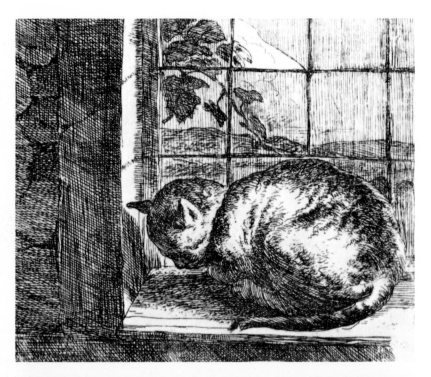

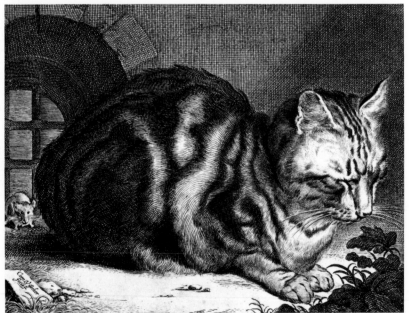

Cat at Window. The seventeenth century in Holland was an era of original etching. Jan Van Ossenbeeck (Dutch, c. 1624–1674), a landscape painter, may have made this etching of a drowsing cat to amuse himself. The cat is not yet fast asleep, for its head is neither high enough nor low enough to allow sleeping, but in that in-between position where cats place their heads before dozing off.

The Large Cat. By Cornelius Visscher (Dutch, c. 1619–1662), this engraving dates from 1657. The title derives from the fact that the cat occupies almost the entire space, although its size is great indeed compared to the mouse who lurks behind it.

Spring Play in a T'ang Garden, detail. When the Metropolitan Museum acquired this silk hand scroll in 1947, it was thought to be by the Chinese emperor Hsüan-tsung (1398–1435); it bears the signature and seals of this Ming dynasty emperor, a noted painter, calligrapher, and collector. Later, scholars questioned its attribution and date, comparing it with other pieces by Hsüan-tsung, and it is now believed to be an eighteenth-century work. No one, however, has ever questioned this delightful garden scene, in which five kittens frolic, as an engaging example of traditional Chinese genre painting.

Metropolitan Cats shows all five kittens from the scroll. In the segment of the scroll on pages 84–85, one kitten proudly carries a bird in its mouth and looks around to see how the others are faring. The front endpaper shows two more of the little cats—a white kitten lolling on its back amid flowers, and a mottled kitten licking its paw. On the back endpaper, another white kitten crouches behind hollyhocks and twists its head to gaze into a tree, probably measuring the distance between itself and a bird that has caught its eye. In the segment of the scroll shown here, one of the kittens naps in a stand of bamboo.

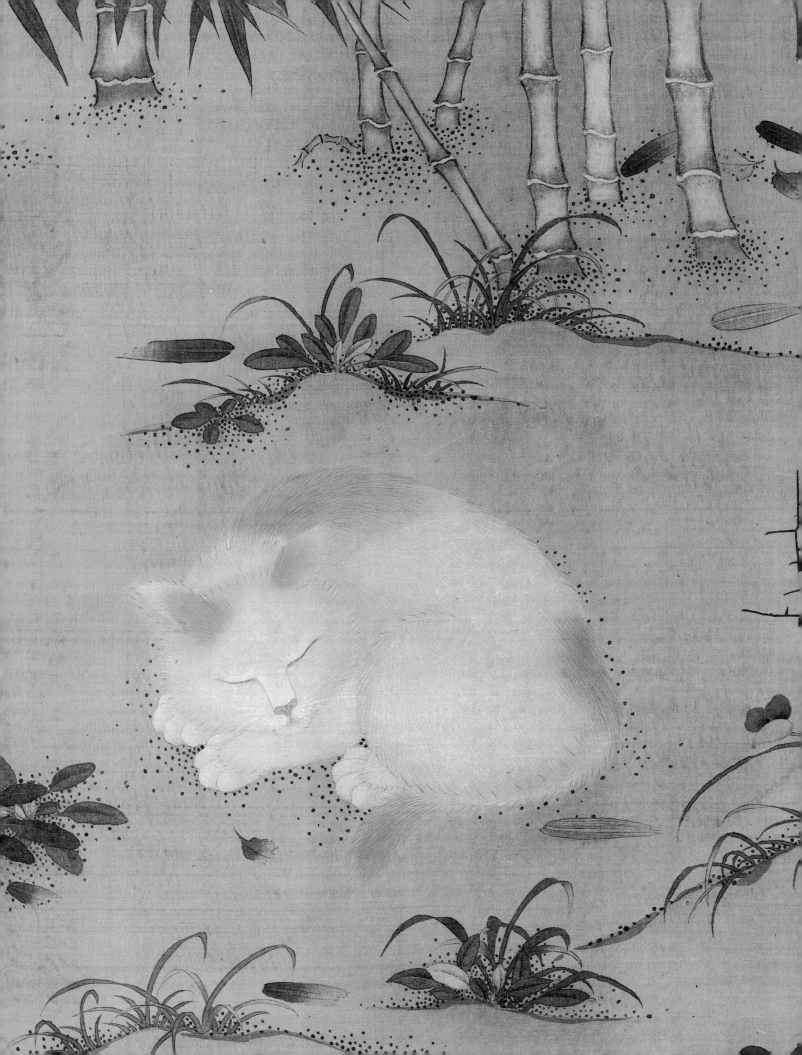

Kitty. This hand-colored engraving is the work of an American printmaker of the early nineteenth century. It was long considered anonymous until the Metropolitan Museum received a letter from Carl Taylor of Washington, D.C., in 1970. Mr. Taylor related that *Kitty* was printed by his great-great-grandfather George White, between about 1821 and 1823. White was born in Cavendish, Vermont, in 1797 and died in Felchville, Vermont, in 1873. The original plate of *Kitty* is on display in the Bennington Museum, Bennington, Vermont.

As a cat portrait, *Kitty* exhibits the same frontward iconic abstraction as Nathaniel Currier's print *The Favorite Cat* (Frontispiece). Both of these felines are placed far forward in the picture plane and project an imposing presence.

Cats in Romantic England were observed somewhat differently. John Keats wrote "To Mrs. Reynolds's Cat" in 1818:

> Cat! who hast pass'd thy grand climacteric,
> How many mice and rats hast in thy days
> Destroy'd?—How many tit bits stolen? Gaze
> With those bright languid segments green, and prick
> Those velvet ears—but pr'ythee do not stick
> Thy latent talons in me—and upraise
> Thy gentle mew—and tell me all thy frays
> Of fish and mice, and rats and tender chick.

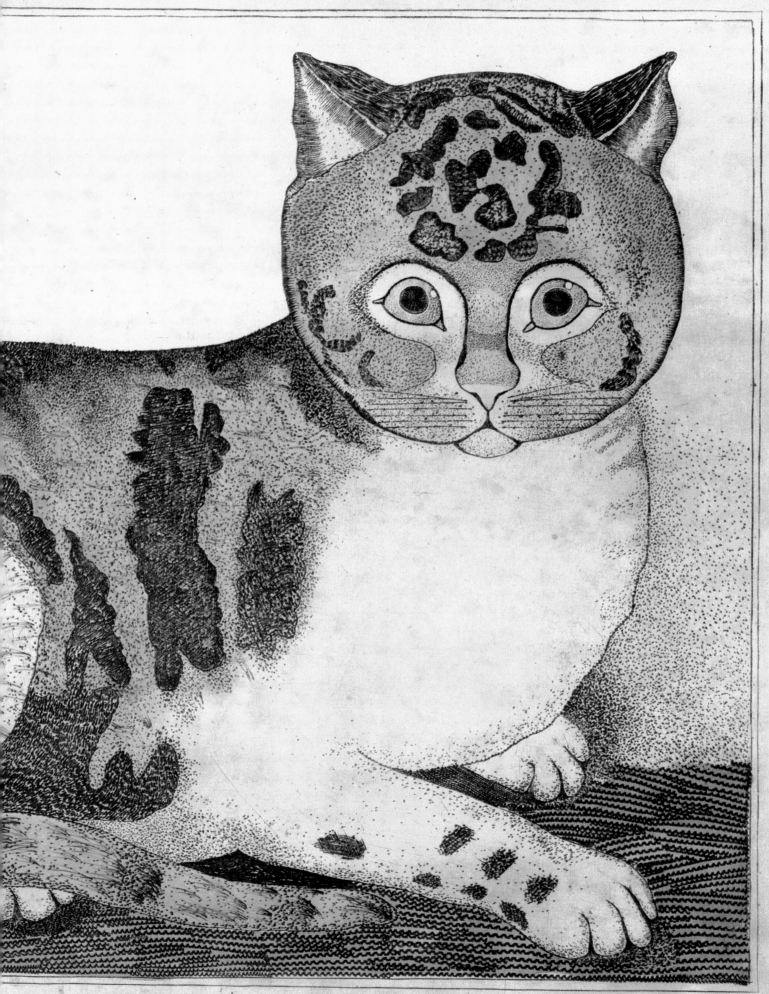

KITTY

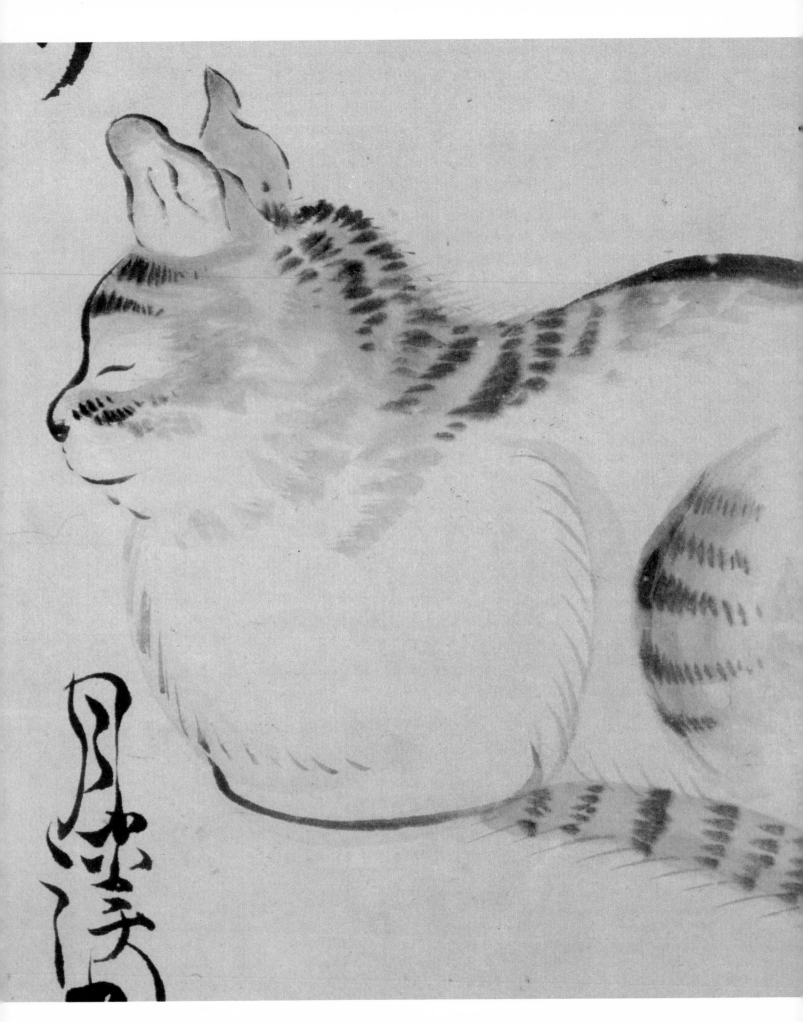

18

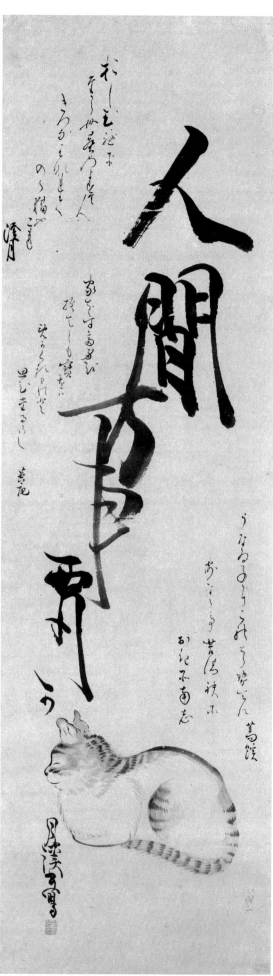

Seated Cat. The meditative cat on this Japanese hanging scroll sits amid poems and a bold calligraphic inscription as if he were in a garden. Mounted on a gold-patterned silk background, the scroll was painted by Matsumura Goshun (1752–1811), an artist of the Edo period. The three poems on the scroll were inscribed by the poets Nishiyama Chogetsu (1714–1801), Ozawa Genchu (1723–1801), and Ban Suke-yoshi, whose dates are unknown but who was also called Kokei.

Goshun, renowned both as a haiku poet and as a *haiga* artist, was a favorite pupil of Yosa Buson, the great eighteenth-century author and artist in the Chinese style. Goshun's style was both simple and direct. The large inscription, a variation on a quotation from the work of the twelfth-century poet Saigyō, reads: "Everything human is Saigyō's cat."

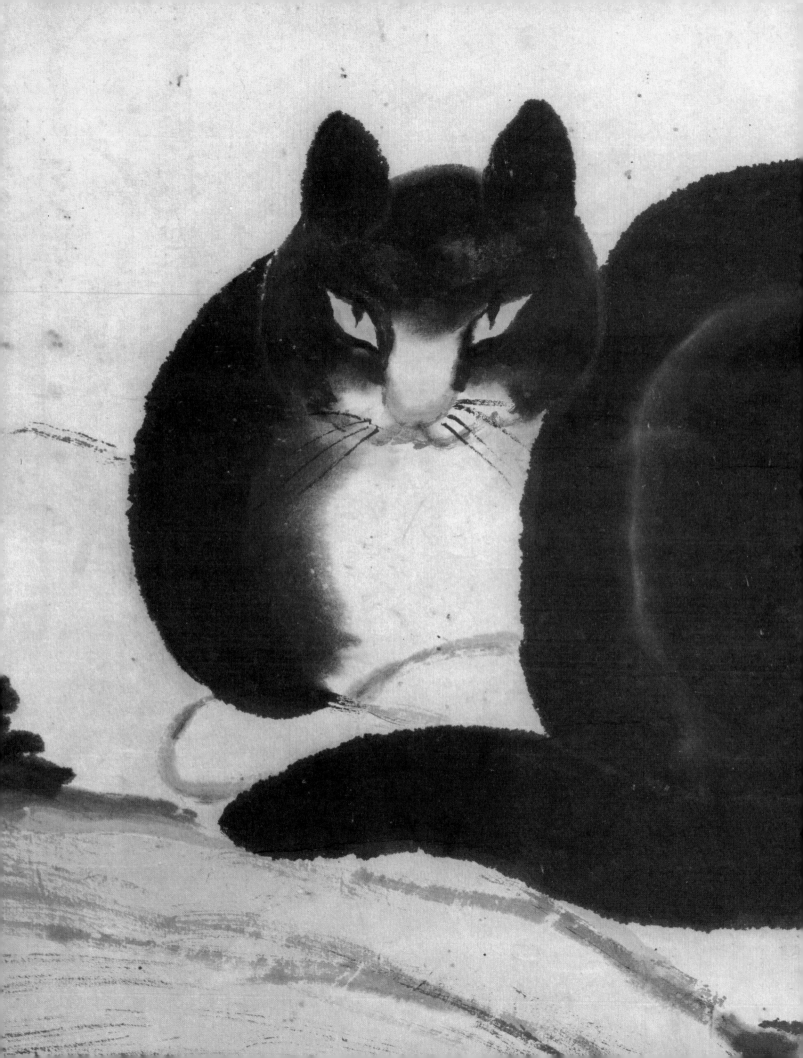

So Tiberius might have sat,
Had Tiberius been a cat.

Matthew Arnold
"Poor Matthias"

Seated Cat. This imperious black and white cat was painted about 1800 by the Chinese artist Chu Ling, whose seals appear on the upper and lower edges of this hanging scroll. In ink and color on paper, the scroll depicts a spring scene in a Chinese garden full of rocks, foliage, and narcissus.

Dominating the scroll, the monumental cat is of an almost overall blackness. Composed of circular forms—haunch, upper torso, and head—his commanding presence projects tensile litheness even though he sits quite still, perhaps awaiting a spring sun.

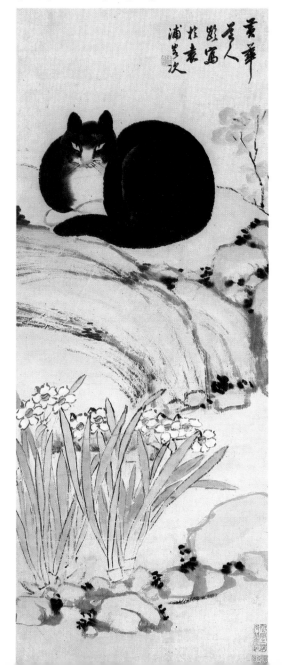

Domestic Scene. Annibale Carracci (Italian, 1560–1609) exhibits here the lightness of touch, freshness of spirit, and sense of enchantment that distinguish his great fresco cycles, such as the one in the Palazzo Farnese, Rome. Executed in pen and ink with gray washes, this drawing from the early 1580s shows a mother warming a child's nightdress before a fire. The family cat also warms himself alongside the hearth.

The Nurse and the Wolf. Francis Barlow (English, 1626–1702) made this illustration for *Aesop's Fables with His Life,* first published in London in 1666. The fable reads: "A Nurse, to make her Bantling cease to cry,/Told it, the Wolf should eat it instantly,/This heard the Wolf, and for his prey he waits,/But the Child slept, and all his hopes defeats./MORALL/Trust not a womans vows, her fickle mind/Is far less constant than the seas, and wind." A cat plays on the floor alongside the infant's cradle in this comfortable seventeenth-century English room. Every detail has been lovingly and faithfully observed by the artist: the broom and bucket, the smoky fire, even the threatening wolf, who sticks his muzzle through the half-open door.

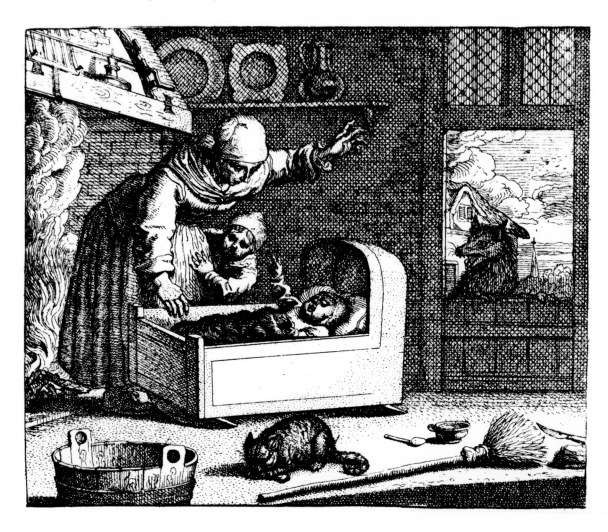

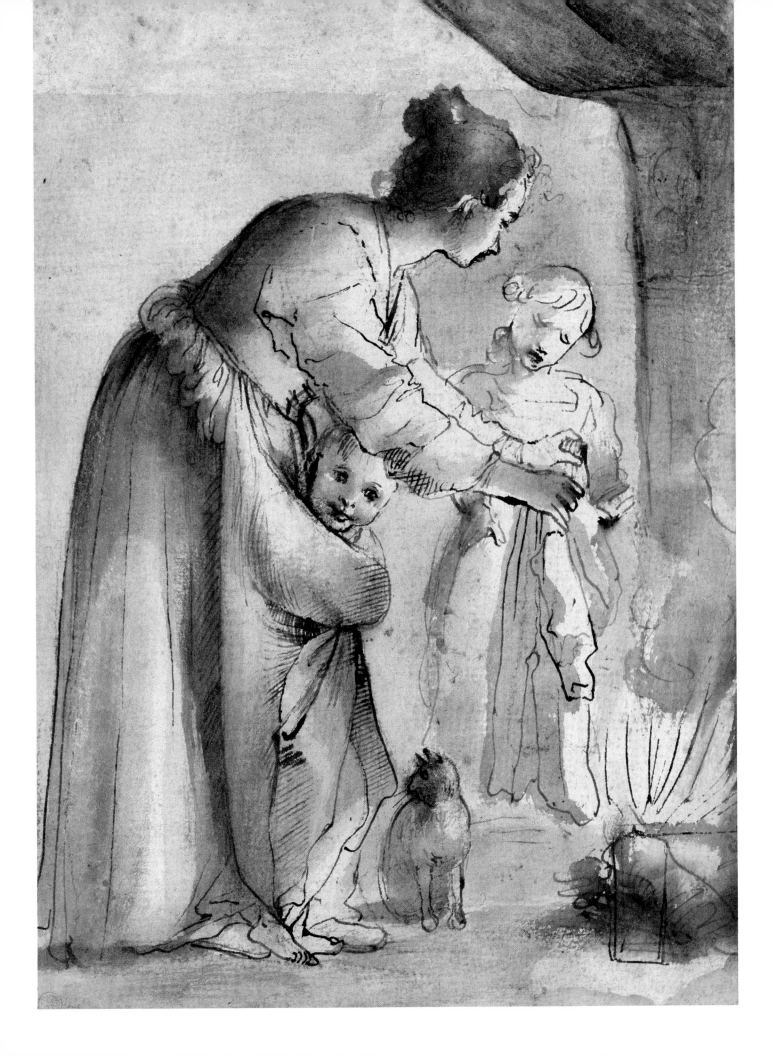

Ipuy and His Wife. The Metropolitan Museum owns a unique collection of more than 365 painted facsimiles of wall frescoes from Egyptian tombs, mainly at Thebes. The original of this painting, showing offerings being made to the sculptor Ipuy and his wife, dates from about 1275 B.C. and was painted in the Tomb of Ipuy at Deir el Medina. Egyptians expected to live in the afterlife as they had lived on earth, and food for the deceased was a matter of great importance. The offering table is usually shown in profile, but the breads, meats, vegetables, and fruit are arranged in vertical tiers to show the whole array.

Perhaps in order that the deceased would feel more at home, a favorite cat or dog is often shown in these scenes. Beneath the chair of Ipuy's wife sits a brown cat who sports a collar and one silver earring. Her kitten plays with part of the sculptor's robe.

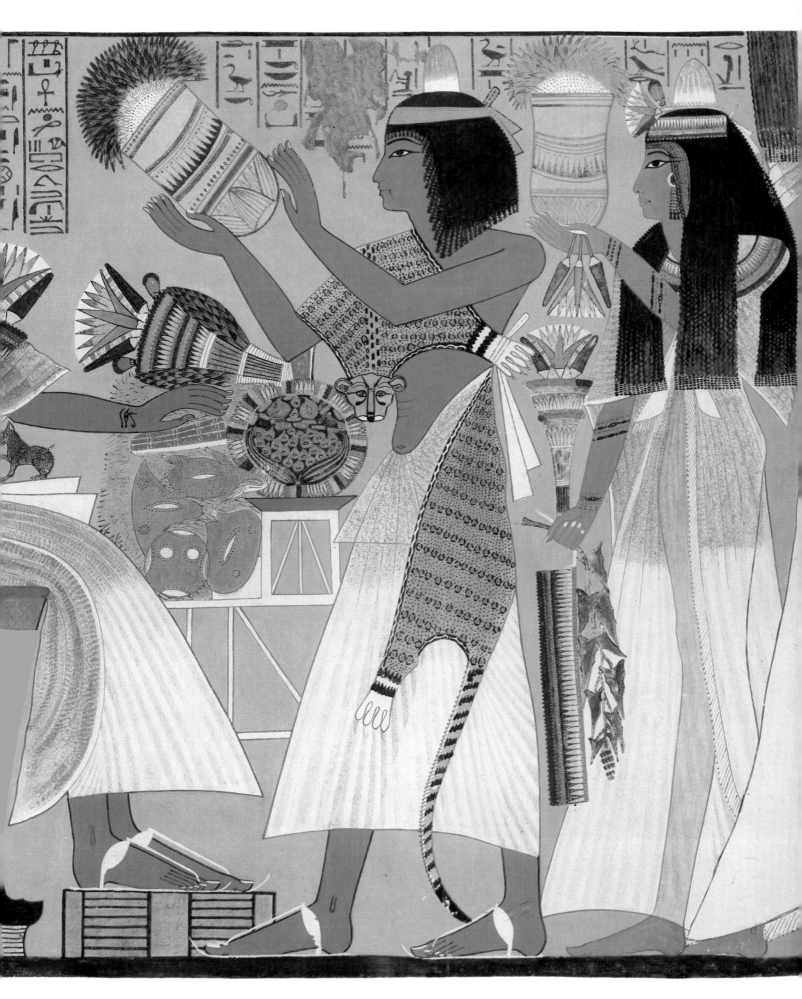

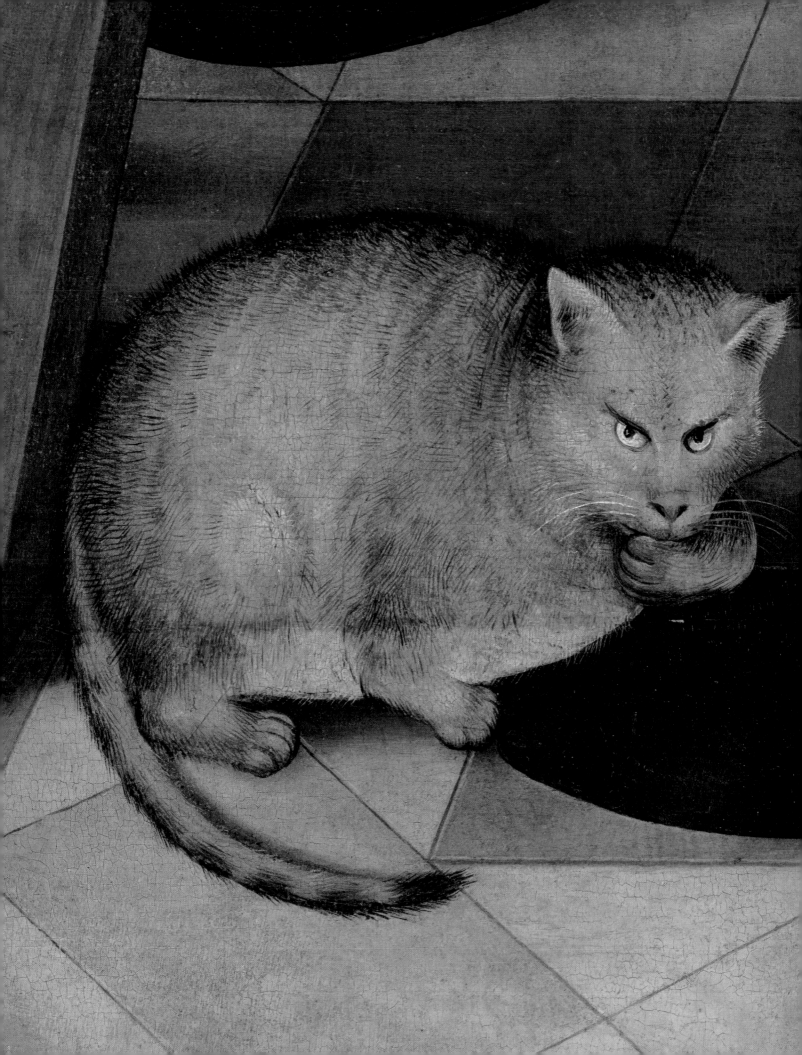

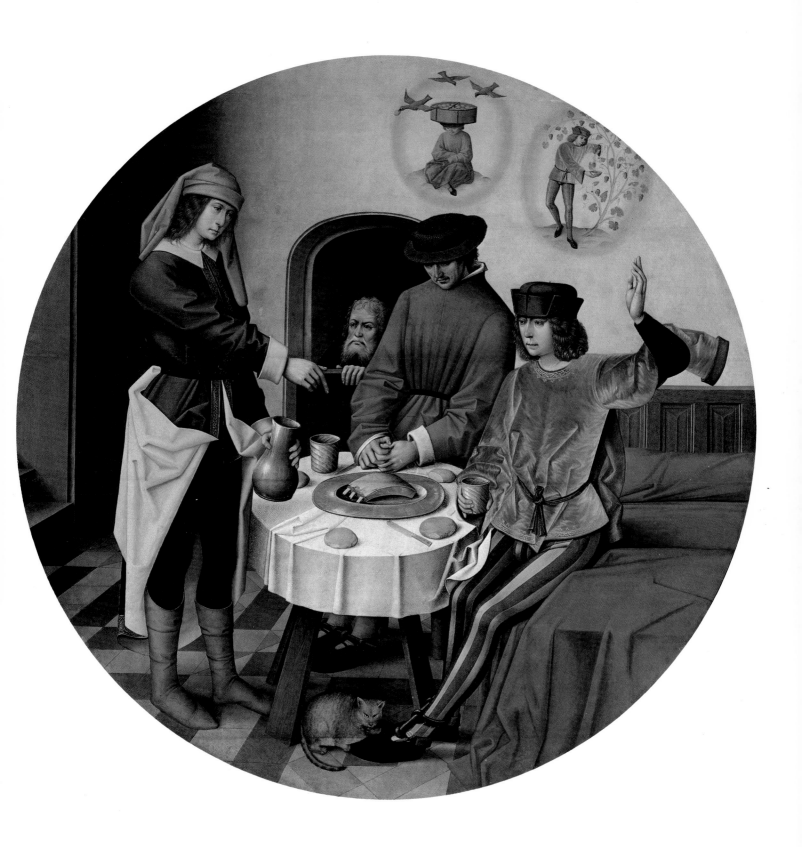

Joseph in Prison. Executed in tempera and oil on wood, by an unidentified Flemish master known as the Master of the Story of Joseph (active c. 1500), this tondo is one of a series detailing the story of Joseph as told in Genesis. The circular format first became popular in Italy in the 1450s, then spread to northern Europe.

Joseph, standing, interprets the dreams of the pharaoh's butler and baker, both imprisoned for offending the ruler. But their conference hardly seems to take place in a prison, despite shackled feet. The setting resembles instead a fifteenth-century Flemish interior. At the butler's foot, a bristly yellow cat cleans his face with his paw.

The Young Mother. In an intimate domestic scene of home and hearth, a woman, paring apples perhaps, keeps an eye on her baby who sleeps in a cradle, and on a hungry cat who appears to be licking up milk. At the back of the room, the curtain over the open door has been hoisted onto a peg to allow a breeze to enter. The drawing, in pen and brown ink with brown washes, has the thick outlines typical of the work of Nicolaes Maes (1634–1693), a Dutch painter from Dordrecht.

Maes became a pupil of the great Rembrandt van Rijn about 1648. From then until the mid-1660s, a stream of portraits and genre pictures issued from his studio, many done in Rembrandtesque style, along with some genre subjects similar to those of Pieter de Hooch. Many of Maes's drawings, including this one, in later centuries were wrongly attributed to Rembrandt.

Dog and Cat. This engraving by Thomas Bewick (English, 1753–1828) is one of his illustrations for a collection of Aesop's fables, originally published in Newcastle-on-Tyne in 1818. The fable reads: "Never were two creatures happier together than a Dog and a Cat, reared in the same house from the time of their birth. They were so kind, so gamesome, and diverting. . . . Still it was observed, that at meal-times, when scraps fell from the table, or a tit-bit was thrown to them, they would be snarling and spitting at one another like the bitterest foes."

Compagnie Française des Chocolats et des Thès. Théophile-Alexandre Steinlen (1859–1923), a French graphic artist who was devoted to cats, made this lithograph for a client about 1899. The predominating bright colors of the poster are anchored by the darker area of the cat, whose strong diagonal crosses the broad arc made by the edge of the table to the center of interest. The realistic tortoiseshell cat has an eye—and a tooth—for one thing only: a taste of the little girl's bowlful of chocolate. He is not at all interested in the cup of tea that Madame is drinking.

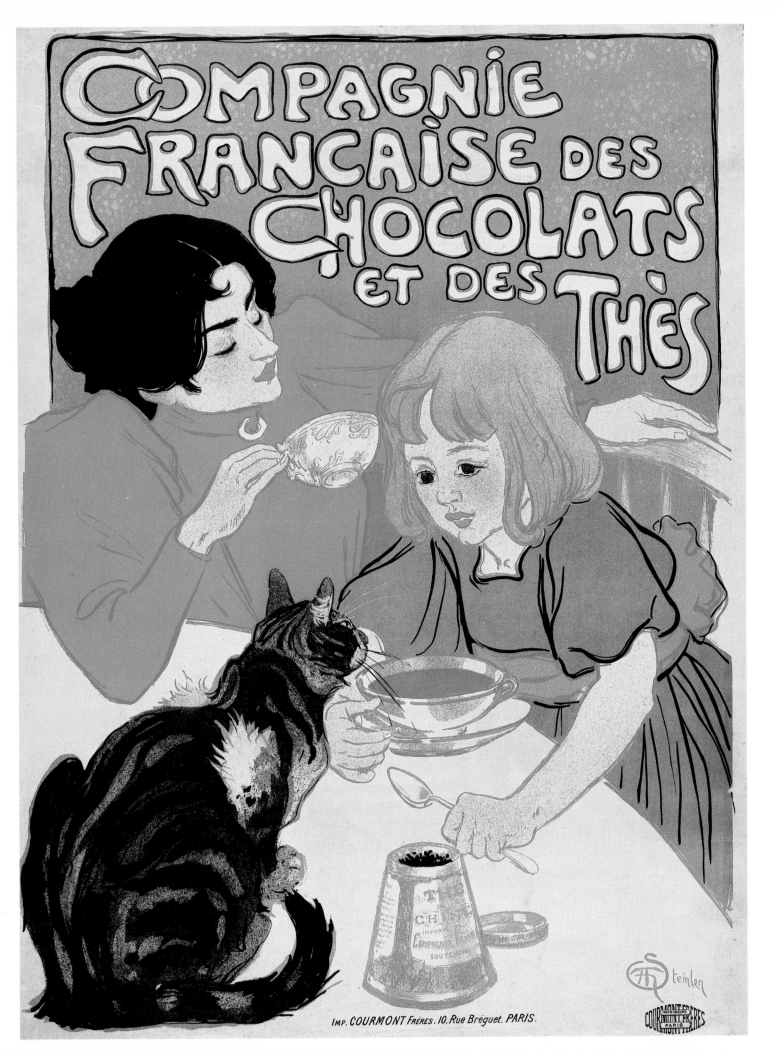

COMPAGNIE FRANÇAISE DES CHOCOLATS ET DES THÈS

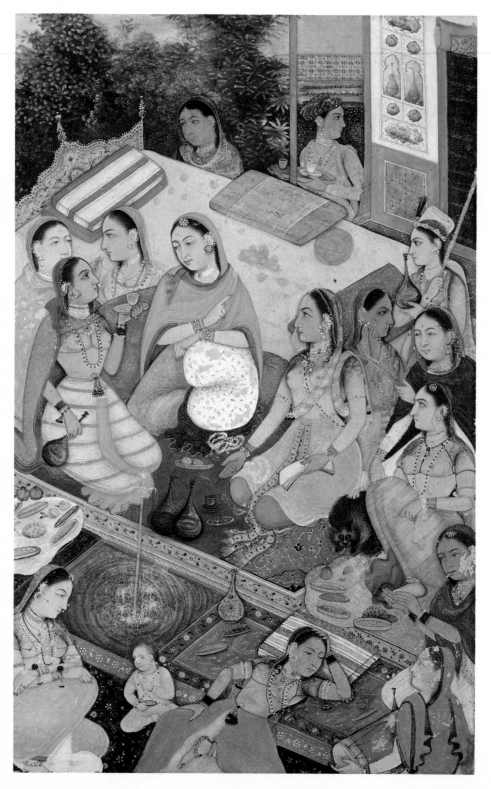

Harem Scene at Court of Shah Jahan. Mughal painting flourished in India during the reign of Akbar (1542–1605), who established an academy of painting in which about one hundred Hindu artists and their students developed their own style, combining elements from Persian, Hindu, and European art. The succeeding emperors, Jahangir (1569–1627) and Shah Jahan (1592–1666), continued to support this new school.

The Metropolitan Museum has an album that contains examples of Mughal art. The album's thirty-three miniature paintings and one drawing include portraits of the emperor Jahangir and his sons Prince Sultan Parviz and Prince Khurram; leisurely views of life at court; and hunting scenes.

In this miniature, the diaphanously garbed and bejeweled women of a *zenana* are sitting and relaxing together. This intimate glimpse of harem life includes a large black cat, which, in the way of cats through the ages, has crept up close to a cloth upon which refreshments, including figs, grapes, and sweetmeats, have been spread. The blue black cat, perhaps a Persian, seems to be the darling of the assembled ladies.

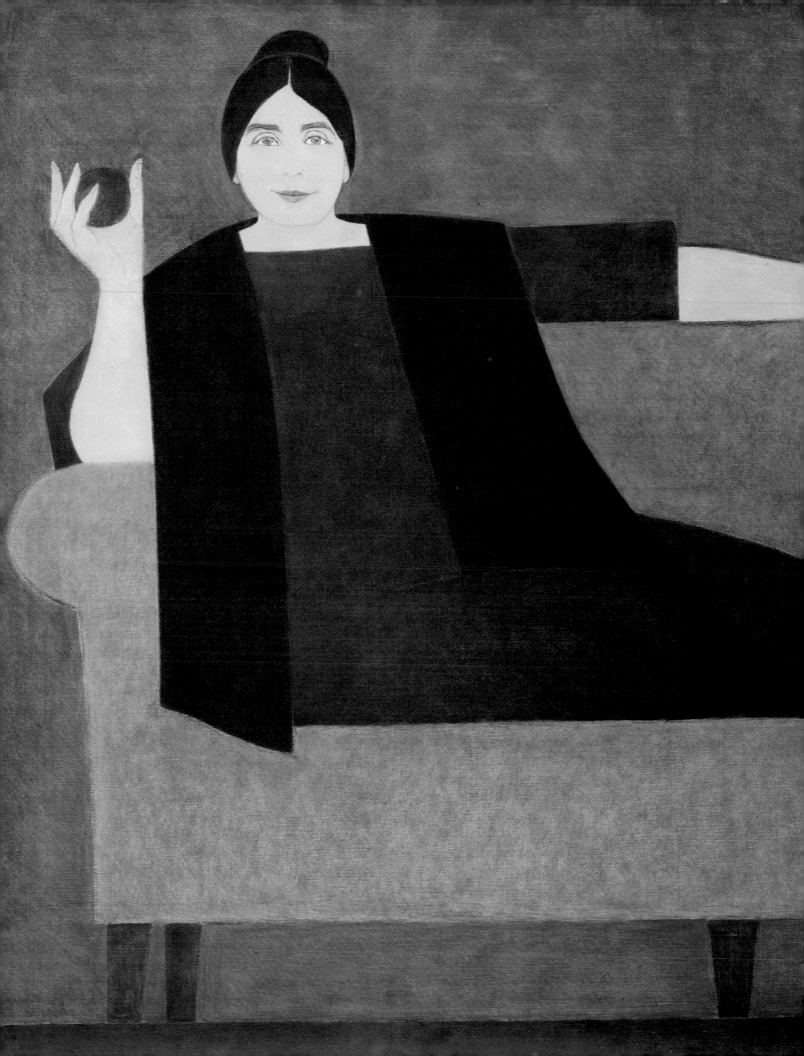

Kiesler and Wife. The contemporary artist and graphic designer Will Barnet (b. 1911) painted this semi-abstract portrait of Frederick J. Kiesler, the architect, sculptor, and theater designer, and his wife, Lillian, between 1963 and 1965. Kiesler, born in Austria in 1892, was a member of *de Stijl* before he emigrated to the United States in 1926.

The figure of Mrs. Kiesler dominates the painting, reducing her husband to the stature of a child. Enigmatically, she holds aloft a red apple as though she had just come from an orchard and wanted everybody to know it. Does she represent the seductress Eve? Or is she about to send a red rubber ball bouncing for the amusement of the black cat?—which makes its ritual appearance here, as in so many works by Will Barnet. Not even the crouching cat, however, can induce the architect to lift his eyes from the blue sheet of paper he so intensely regards.

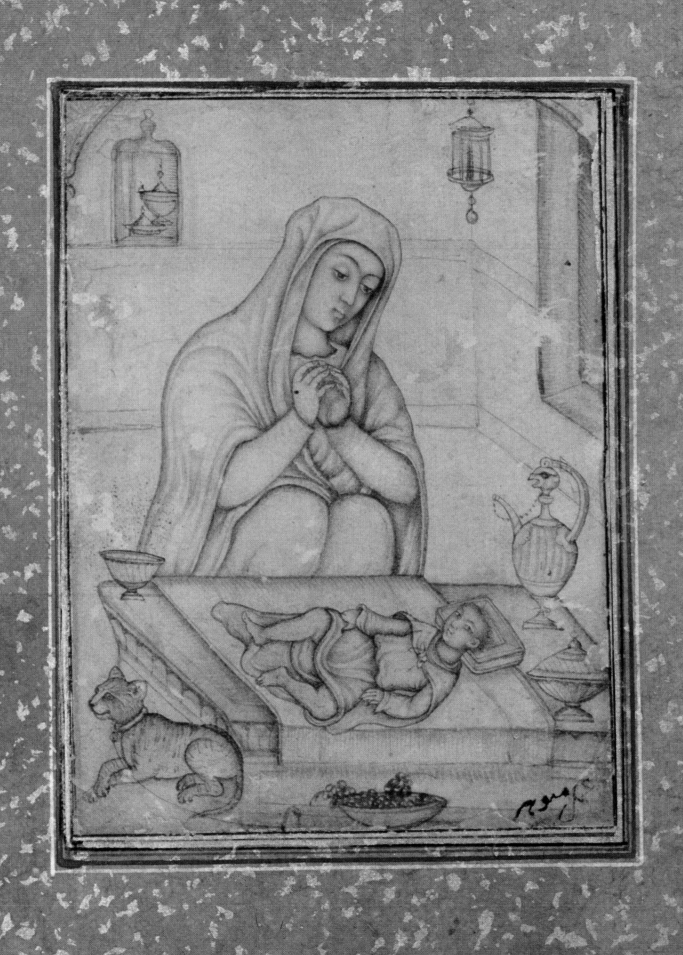

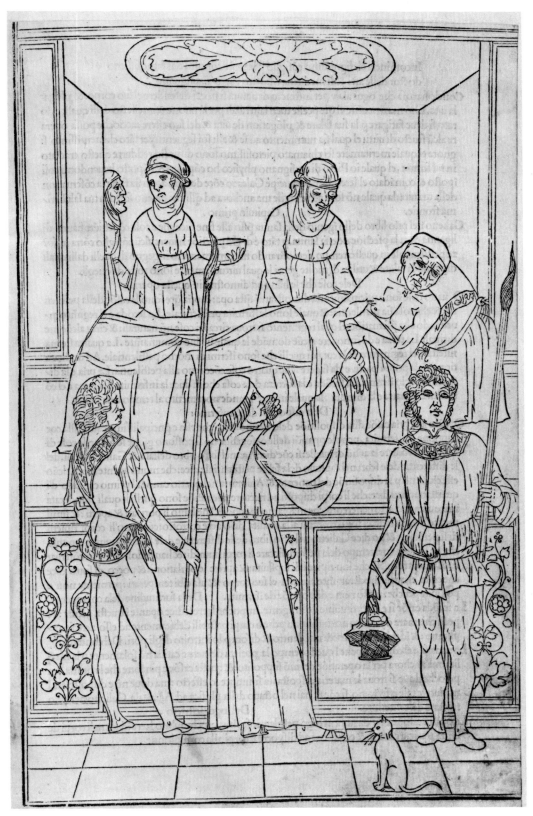

Mughal Virgin and Child. The Mughal emperor Jahangir (1569–1627) was not only fascinated by Christianity but was also deeply sensitive to art. Bearing witness to his expertise are two albums that he assembled, called *muraqqas,* containing Persian and Mughal miniatures, some executed after European models, interspersed with European prints. This drawing comes from just such a collection. Adapted from a European engraving, it shows the Virgin Mary adoring the Christ Child in a room combining Islamic and European elements. At the foot of the Child's bed, the Mughal artist has placed a tranquil cat, whose crossed paws suggest the attitude of the Lamb of God.

Man with the Plague. The illustrations in the *Fasciolo di Medicina,* an early medical anthology by Johannes de Ketham, published in Venice by Gregoriis in 1493/94, have been called the most grandiose woodcuts in any Venetian book before the age of Titian. They may have been based on drawings by the painter Vittore Carpaccio.

In a chamber within a rich Venetian house, a man suffering from plague lies abed while three women of his household attend him, and a doctor and two assistants with torches administer to him from a safer distance. The doctor takes the pulse of the sick man, with the household cat in attendance.

Just Moved. Few paintings of American interiors of the mid-nineteenth century exist. Those that do, such as this one by Henry Mosler (American, 1841–1920), serve as background either to portraiture or genre subjects. Born in New York, Mosler studied painting in Europe and America and made an international reputation. This 1870 painting must have appealed to the sentimental taste of its day. The collection of household items strewn about the room is a summary of country antiques at today's auctions.

A young family of four plus black and white cat have just moved themselves and their belongings into new quarters. The mother holds the infant in her lap while the father cuts bread and cheese for their first repast in their new home. The father rests his feet on a cast-iron stove that awaits installation. On the pie safe in the corner rests a wicker basket, a clock in the Gothic Revival style, and a glass cruet set in a stand. Carved bedposts, a washboard and tub, a traveling trunk, and a hot-water boiler also clutter the room.

Why has the cat been tethered by a cord to the boiler? Does he bother the child, or will he try to run back to their old lodgings? Or will he create havoc if freed to rummage in all the packed-up goods?

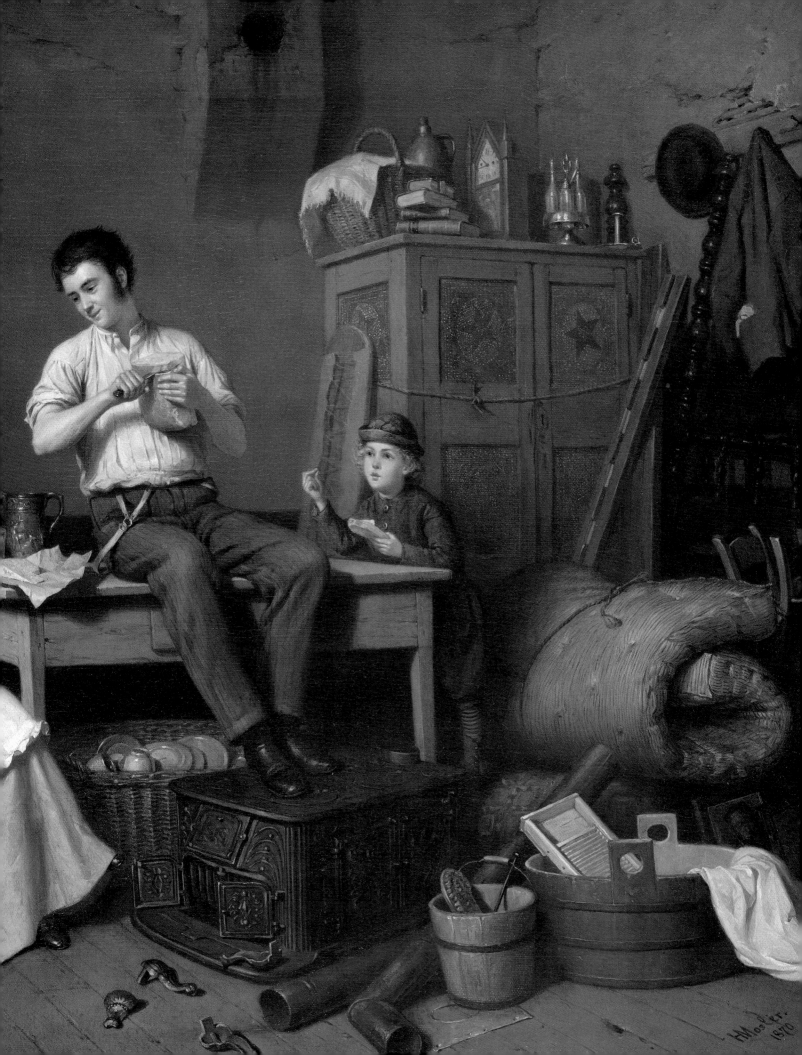

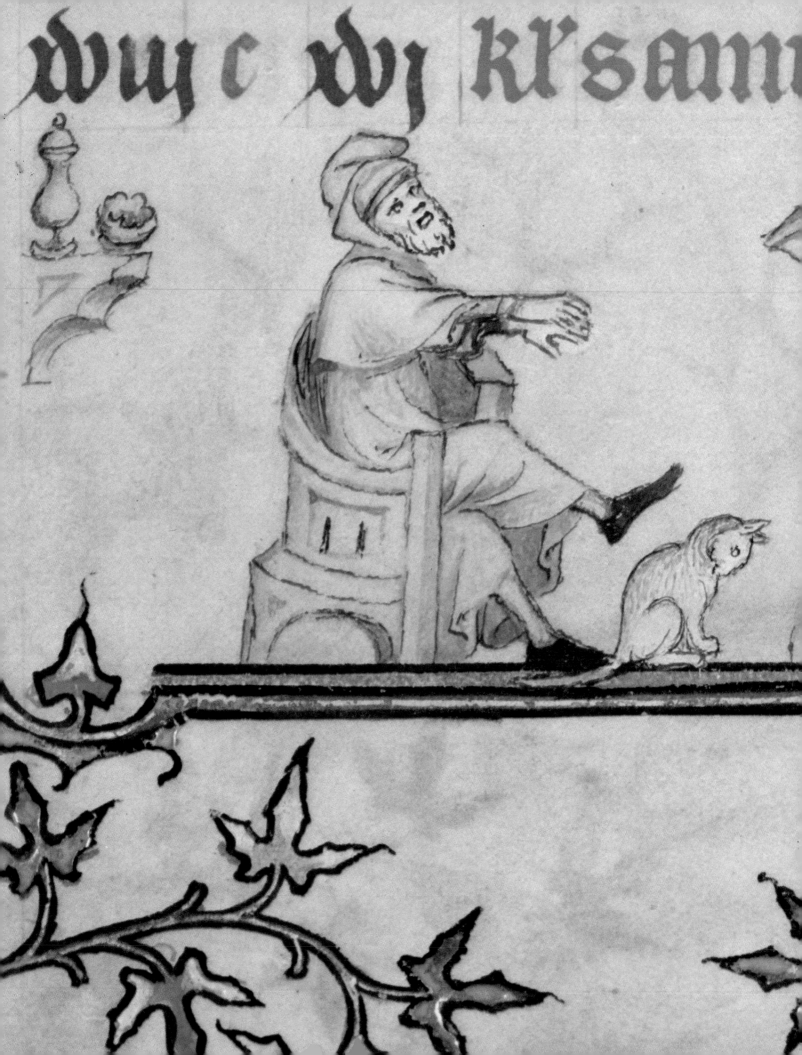

Bas-de-page. Jean Pucelle (fl. c. 1324–1327) fused three great streams of art into a new style for medieval France: the elegance of Parisian manuscript illuminators; the *drôleries* of English Channel artists; and the spatial conceptions of the Italians. In addition, he conveyed a sense of charm and emotion in his figure groups. These are precisely the qualities in this *bas-de-page,* or lower part of a folio, from the *Psalter and Prayer Book of Bonne of Luxembourg.* This devotional book was made in the style of Pucelle, probably about 1345 for the wife of Jean le Bon, the future king of France.

The *bas-de-page,* here greatly enlarged from its actual width of about 3⅝ inches, presents a delightfully cozy scene. Before a central fire, a rich man in red nightcap and nightshirt warms his hands and slippered feet, while a gray cat dozes on the hearth. Two servants tend the blaze so that their master will be warm throughout the night: one uses a bellows, the other brings a load of wood. A pot hangs over the fire to warm the master's meal; behind him, a wall shelf holds a covered goblet and a dish.

41

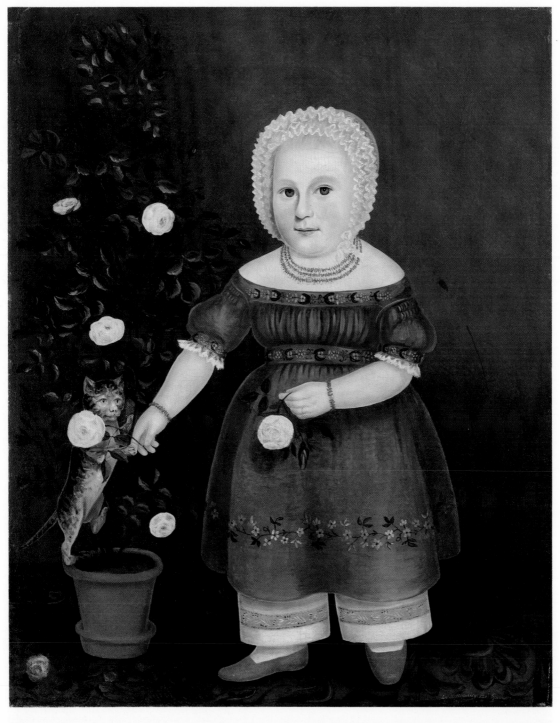

Emma Homan. The nineteenth-century American folk painter John Bradley (active 1832–1847) practiced his trade of "portrait and miniature painter" at different New York locations: his first studio was at 56 Hammersley Street in 1836/37; his second, 128 Spring Street from 1837 to 1844. Painted in 1843/44, this charming portrait of Emma Homan (1842–1908), later Mrs. Emma Homan Thayer, may have been made in Bradley's second studio; the work is signed in the lower right in yellow paint "by J. Bradley 128 Spring Street." But according to family tradition, the portrait was painted at a small village near Riverhead, Long Island.

The chubby child, who bends aside a rose from the small tree in order to reveal her cat, grew up to be an artist herself and illustrated two books—*Wild Flowers in Colorado* (1885) and *Wild Flowers of the Pacific Coast* (1887). The gray cat, too, shows an interest in flowers, as the broken and torn rose petals on the carpet attest.

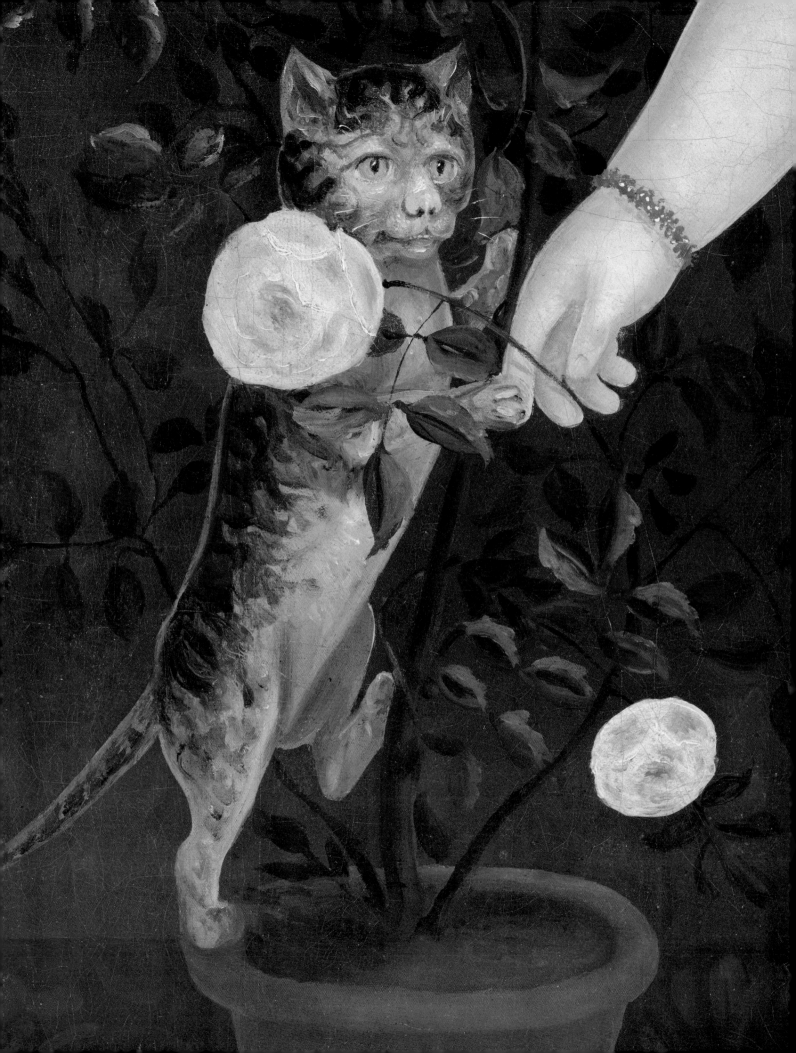

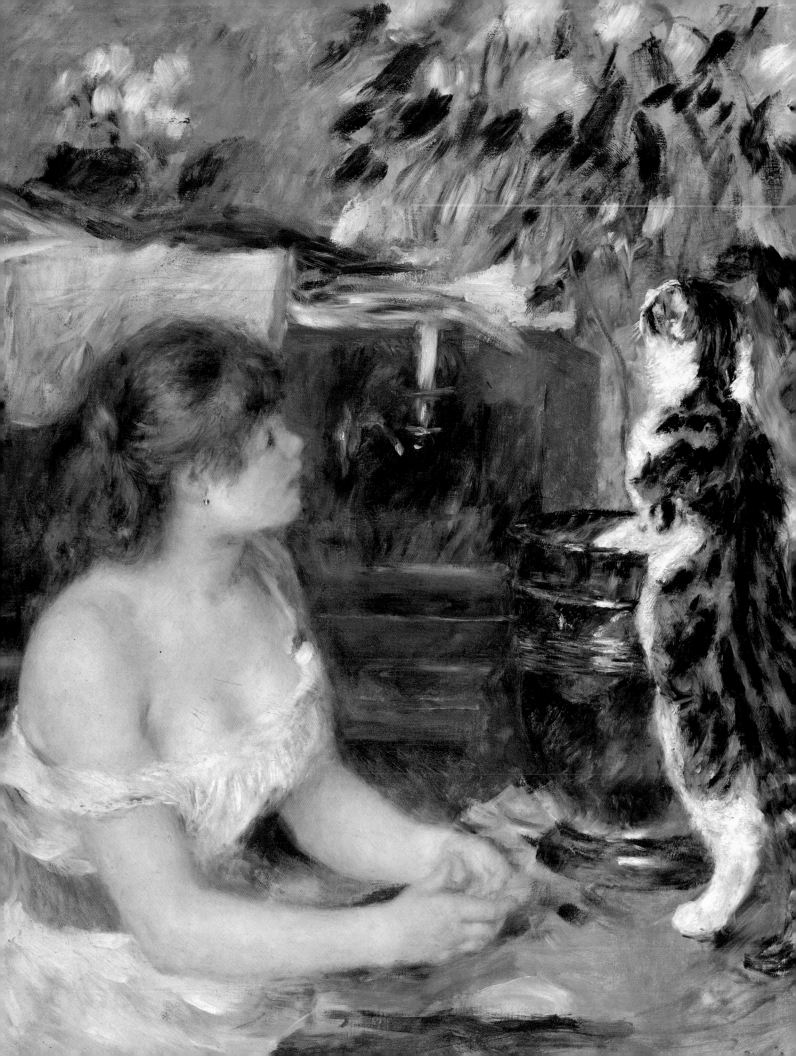

Young Woman with Cat. No matter how often they are shooed away, cats are irresistibly drawn to plants and flowers. Pierre Auguste Renoir (French, 1841–1919) painted an auburn-haired young woman with a tortoiseshell cat standing on its hind legs and climbing into a cachepot that holds two plants.

In this oil on canvas of about 1880–82, Renoir displays his virtuosity in varying his technique and in handling paint. The skin of the model—Aline Charigot, who became the artist's wife in 1890—has been smoothly and sensuously painted, and resembles the skin of a peach. Elsewhere, the paint is either so thin that the canvas shows through, or, as in the fur on the cat's back, it is a thick impasto that Renoir built up by pressing his color-laden brush against the canvas.

Le Chat et les Fleurs. Edouard Manet (French, 1832–1883) contributed this engraving for *Les Chats,* the first major study ever published on cats. Written in 1870 by Champfleury, pen name of the French journalist Jules Husson (1821–1889), *Les Chats* contained illustrations by other artists of the modern period and of earlier times.

The marauding cat prowls among the flowering plants in a small conservatory or sitting room. It seems as though he has already devastated the flowers in the sturdy, three-legged cachepot to the right, and is walking off with his haul.

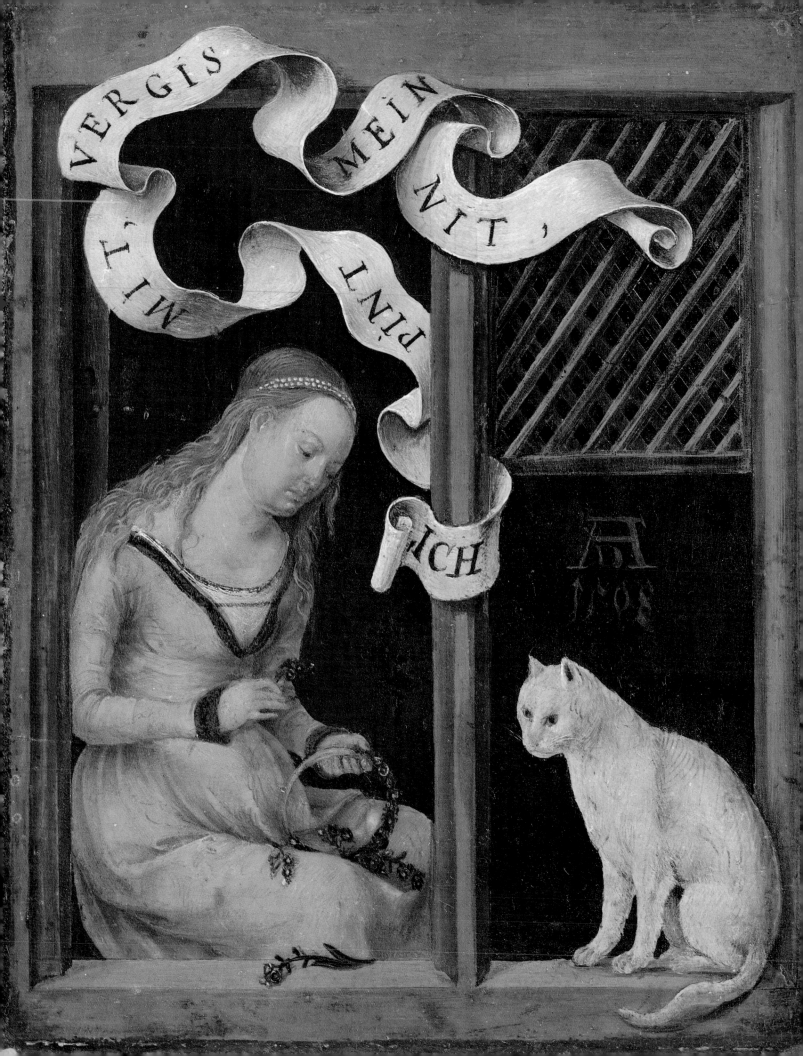

Girl Making a Garland. This wooden panel of about 1508 is painted on both sides in tempera and oil. On the side shown, a young woman works in a window seat while her pet cat looks on. A scroll bearing the words ICH PÍNT MÌT, VERGÍS MEÌN NÍT ("I am here, do not forget me") winds around the casement post. On the reverse is a portrait of a young man, for whom the scroll's sentiments are probably meant.

During the Middle Ages, many saints were associated with cats, both good and evil. Saint Gertrude of Nivelles was the patroness of cats. Saint Agatha was also called Saint Gato, or "Saint Cat." Saint Yves, patron of lawyers, was often shown with a cat, symbolizing lawyers' evil qualities.

The panel is falsely signed with Albrecht Dürer's monogram AD in the right center; actually, it is the work of Hans Süss von Kulmbach (German, c. 1480–1521/22), Dürer's contemporary.

Mother, Child, and Cat. This decorative lithograph is by an unidentified member of the Wiener Werkstätte, an association of artists and craftsmen founded in Vienna in 1903. The graceful composition exemplifies its goals of harmony and proportion in all aspects of the design of furniture, graphics, and personal items.

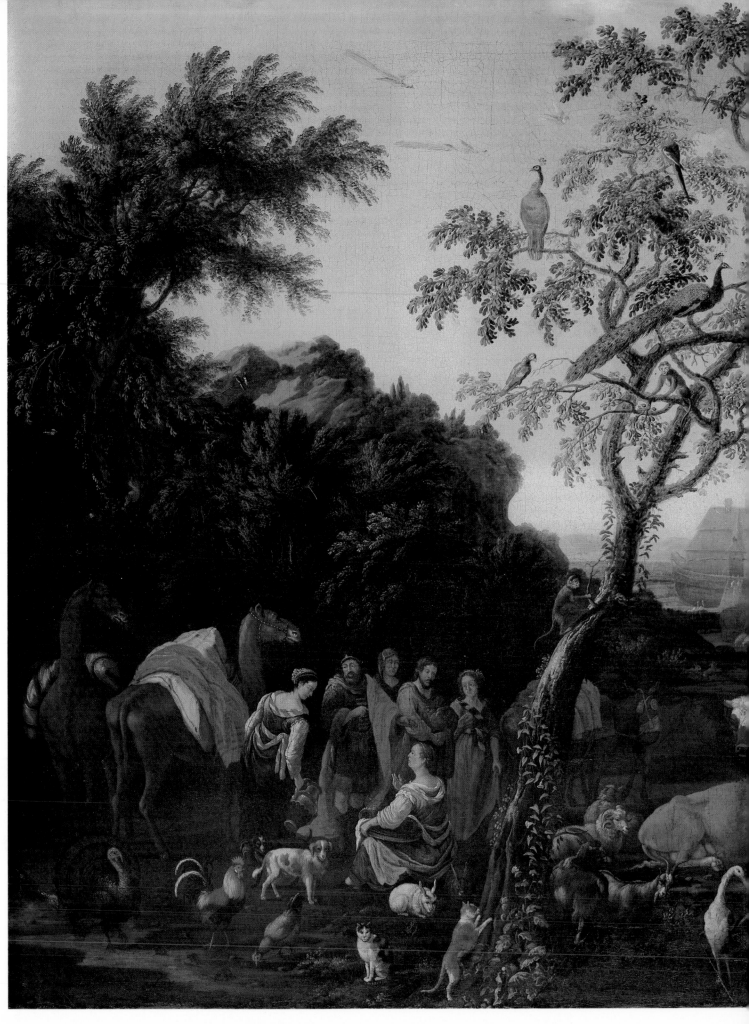

48

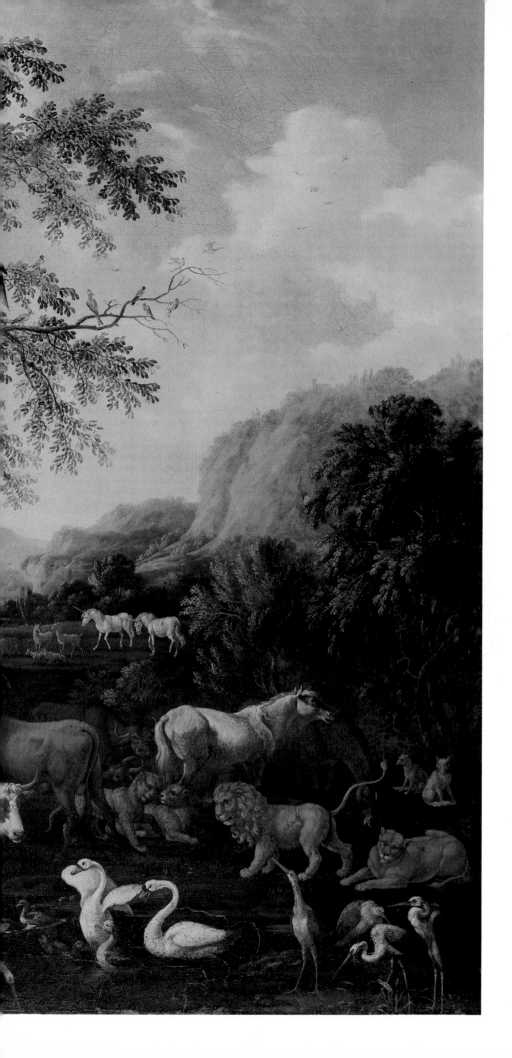

The Ark. Once attributed to Jacob Hogers (1614–1641), this work was probably painted by an unknown Dutch artist in the late seventeenth century. Domestic, wild, and fantastic animals and birds have gathered in pairs to board the ark. Front and just off center are two cats—one pensively waiting, the other about to chase a monkey up a tree. The two strangely drawn camels are obviously based on drawings by other artists and on hearsay. Near the ark in the background, two elephants graze not far from a pair of unicorns.

Who are the six people to the left? The four women and two men must be Noah and his wife, a son, and two daughters-in-law. Two of his sons are missing; perhaps they are collecting more animals and birds.

Lady with Her Pets is the earliest known painting by Rufus Hathaway (1770?–1822), an American primitive painter who worked in Duxbury, Massachusetts. After Hathaway married in 1795, his father-in-law persuaded him to study medicine, and as a physician he painted only in his spare time.

The woman in this portrait is thought to be Molly Whales Leonard, probably a member of the Leonard family of Marshfield, Massachusetts. Mrs. Leonard, in her Sunday best and in full plumage, has been painted in a bold linear pattern. Her unconventional pets include a black cat with a white nose and yellow eyes, a parrot, a robin redbreast, and two butterflies; this menagerie seems to constitute her own Peaceable Kingdom. The inscription "Canter" in the lower left corner of the painting is probably the cat's name.

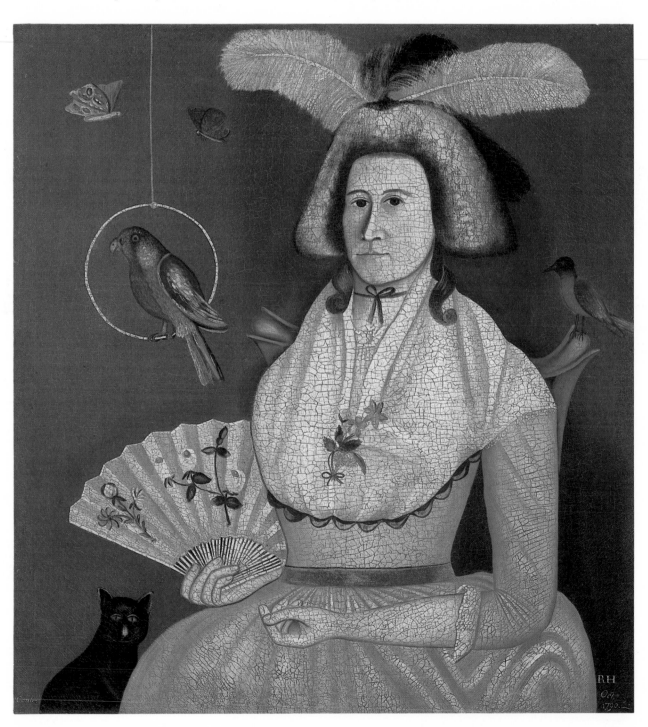

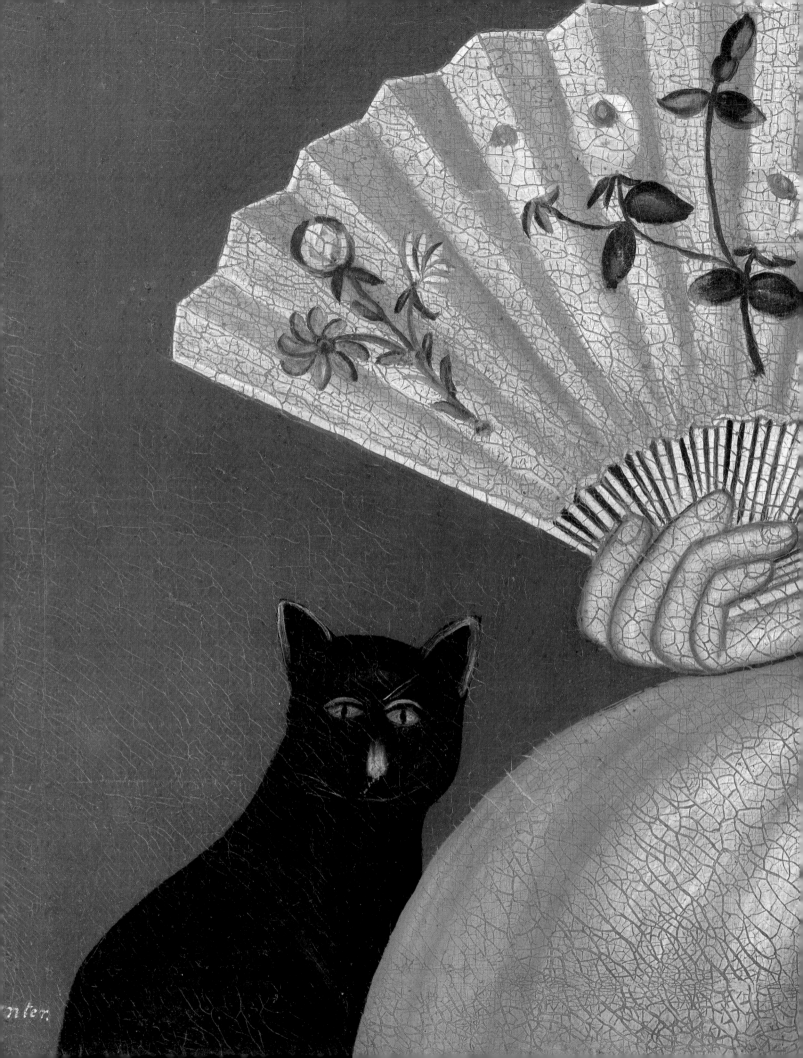

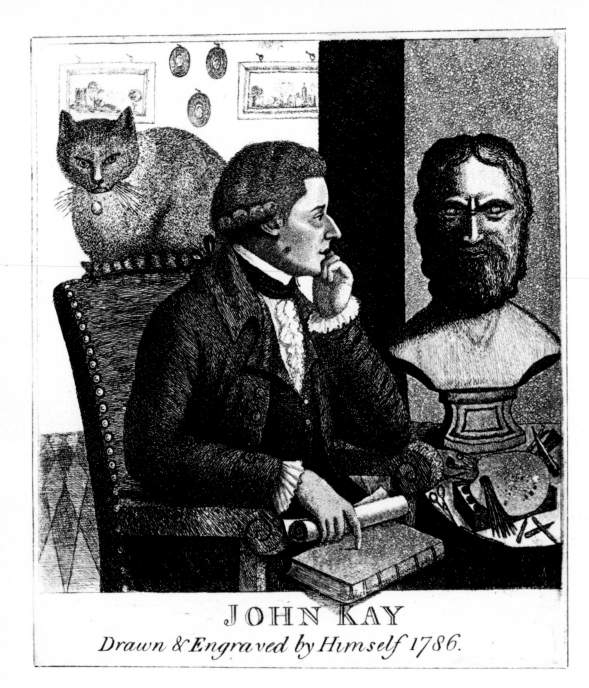

JOHN KAY

Drawn & Engraved by Himself 1786.

Self-Portrait with the Bust of Homer. John Kay (Scottish, 1742–1826) executed this etching with aquatint when he was forty-four years old. Kay described the print: he drew himself, he said, in a thoughtful posture; his favorite cat, believed to be the largest in Scotland, sitting on the back of his chair. In his hand is a scroll of artist's paper, and "a volume of his works" rests on his knee—surely wishful thinking, for Kay published no such volume during his lifetime. As Kay contemplates Homer, so the cat concentrates sternly upon us.

Amelia C. Van Buren and Cat. Led by his quest for realism in artistic expression, Thomas Eakins (American, 1844–1916) attended medical classes to improve his knowledge of anatomy and became a photographer to see how the camera's eye might instruct his own. About three hundred of his photographs survive, but only this one features a cat with a person. Eakins photographed Miss Van Buren at least four times about 1891, and he painted a portrait of her that year. Here an affectionate cat poised on her shoulder looks appealingly toward the camera.

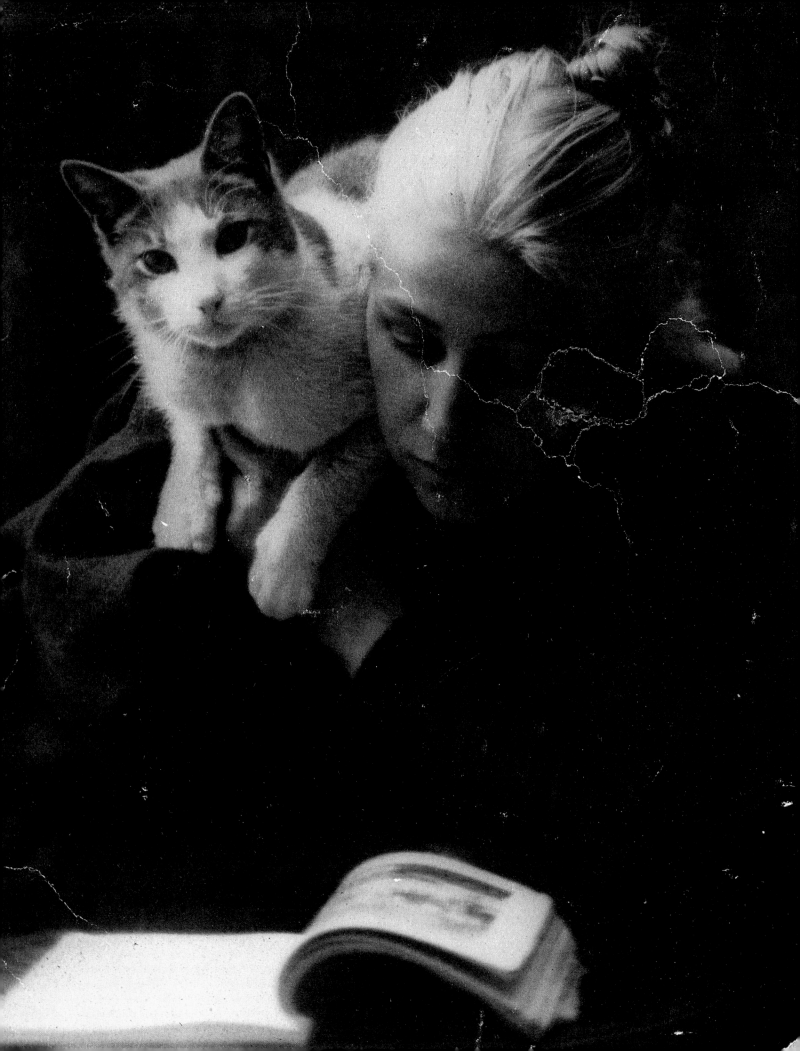

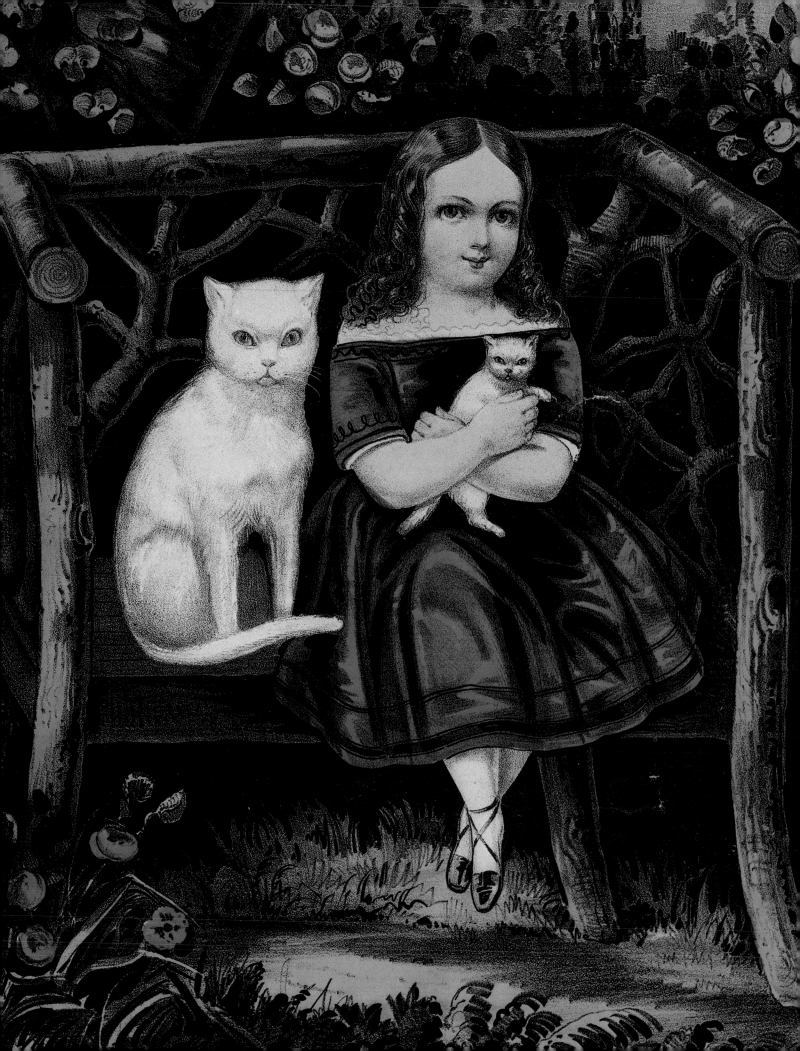

The Little Pets. Lithographed by Currier & Ives, a young Victorian miss in a velvet dress and patent leather shoes poses primly with her pets, a mother cat and kitten, in a rustic garden seat surrounded by flowers. The mother cat, too large in proportion to the girl, is almost one-dimensional, resembling a paper cutout. The scene, a sentimental one even for Currier & Ives, decorated many Victorian parlors.

Martha Bartlett with Her Kitten. Found in Mount Vernon, Maine, this portrait was painted in the second quarter of the nineteenth century by an unknown American primitive artist, possibly an itinerant painter. Many little girls in early America were painted sitting or standing in their best dresses, holding their cats. Perhaps the proximity of a loved pet helped the child to stay still longer, thus permitting the artist to accomplish his task. Somber in tone, stiff in pose, and with an unhappy expression, Martha nevertheless holds her kitten tenderly. The white-stockinged cat, unlike its owner, seems quite relaxed.

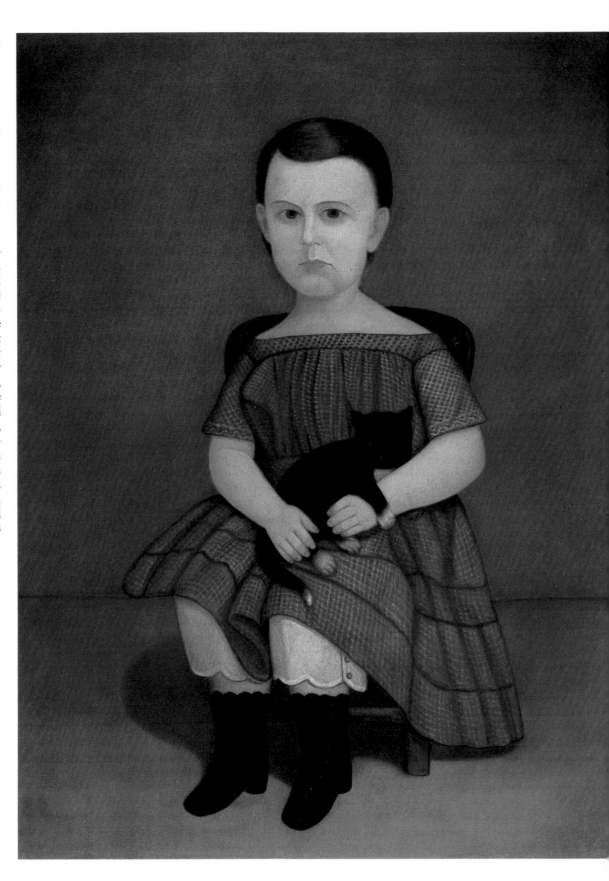

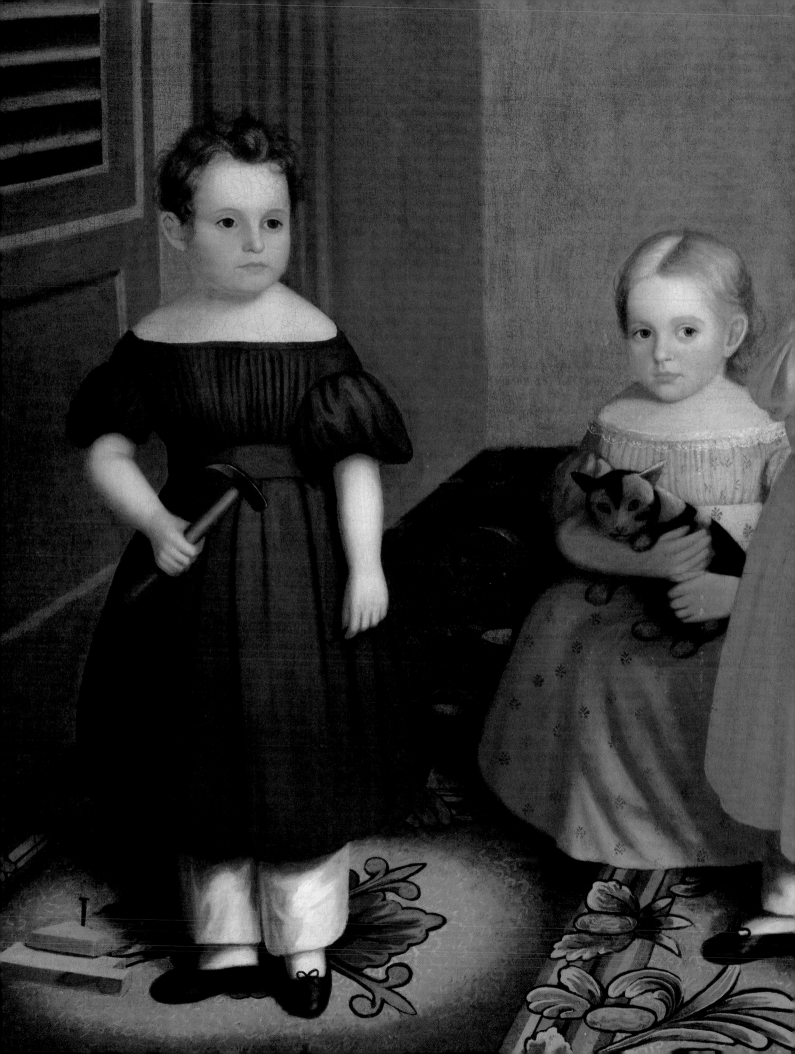

The Alling Children. The four little girls of this painting were the daughters of Mr. and Mrs. Stephen Ball Alling of Newark, New Jersey. Eunice (left) holds a hammer; next to her the youngest, Jane, cradles her black and white cat. Cornelia, the oldest, stands next to Emma, who clasps a Bible.

Mrs. Alling was originally from Belfast, Ireland. She and her husband were devoted friends of the Irish patriot Robert Emmet, and Stephen Alling was incarcerated in the Tower of London along with Emmet to be beheaded. Jane Weir Alling appeared in court and told the prosecutor, "If you would take my protector, at least leave me his sword!" The magistrate in charge banished the couple, penniless, to the United States.

This American primitive painting is by Oliver Tarbell Eddy (1799–1868), who was born in Vermont and studied engraving with his father. An inventor as well as an artist, he numbered among his patents one for an early version of a typewriter.

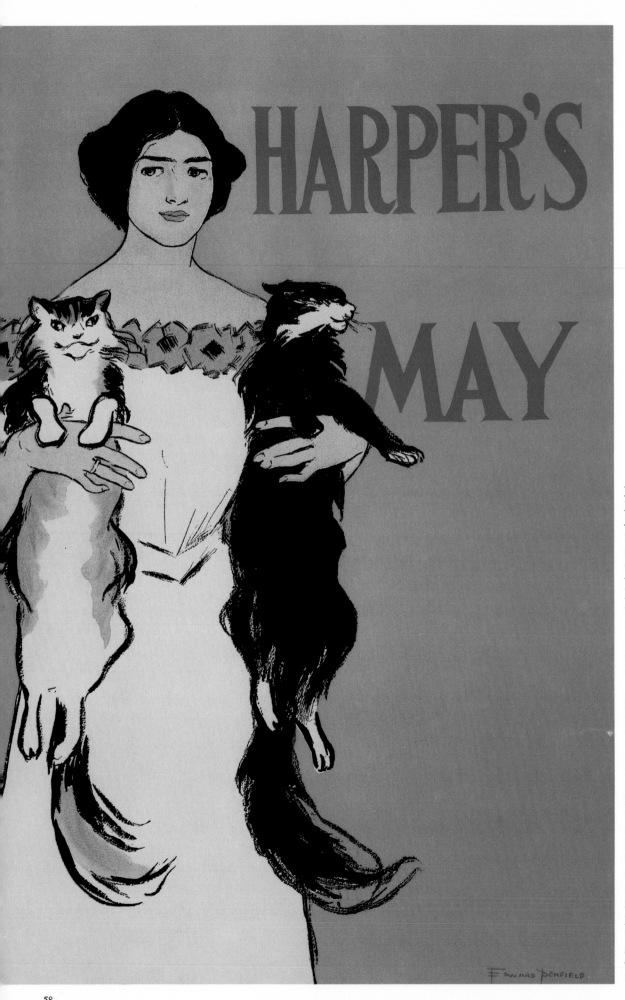

Harper's May. Advertising the May 1896 issue of *Harper's Magazine,* this lithograph shows the technical ease and design sense of Edward Penfield (American, 1866–1925). A statuesque woman closely holds her two large cats, both with voluminous tails, in a manner that cats generally dislike. But these grinning pets seem supremely content to be just where they are.

May Belfort. At the height of his career, Henri de Toulouse-Lautrec (French, 1864–1901) designed this poster of the Irish singer May Belfort holding a black cat against her bright red dress. Printed in Paris by Kleinmann, the poster shows the deep influence of Japanese prints, a style pervasive in French art of the late nineteenth century. Toulouse-Lautrec created many posters such as this one, featuring his favorite subjects—chanteuses, circus performers, actresses, and equestriennes. His well-known monogram *au japonais*—a circle containing his initials HTL—appears at lower left.

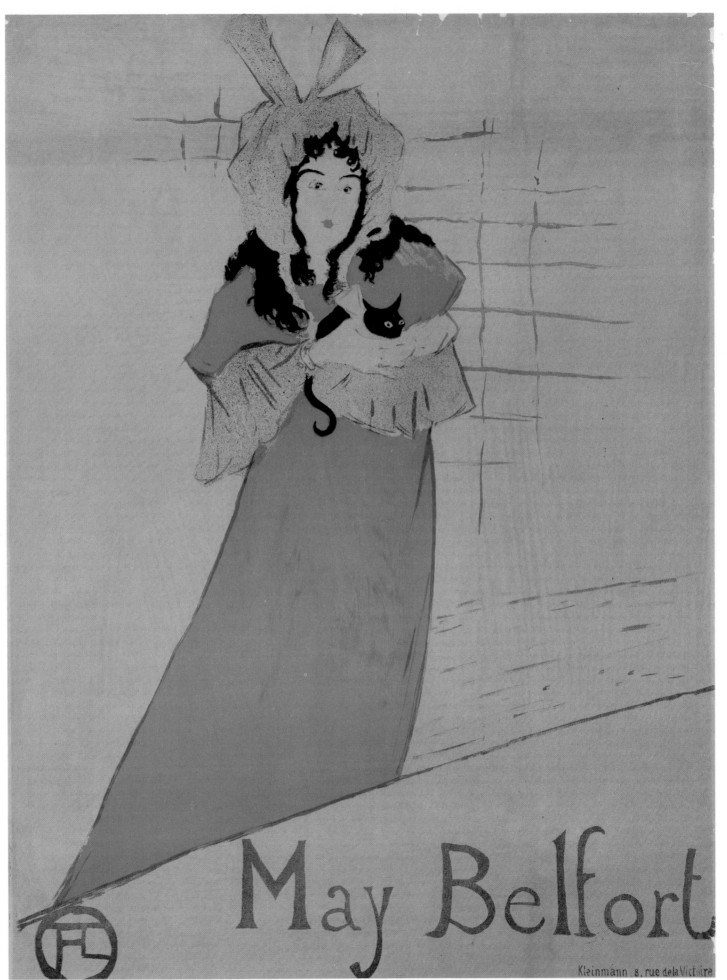

May Belfort

Kleinmann 8. rue de la Victoire

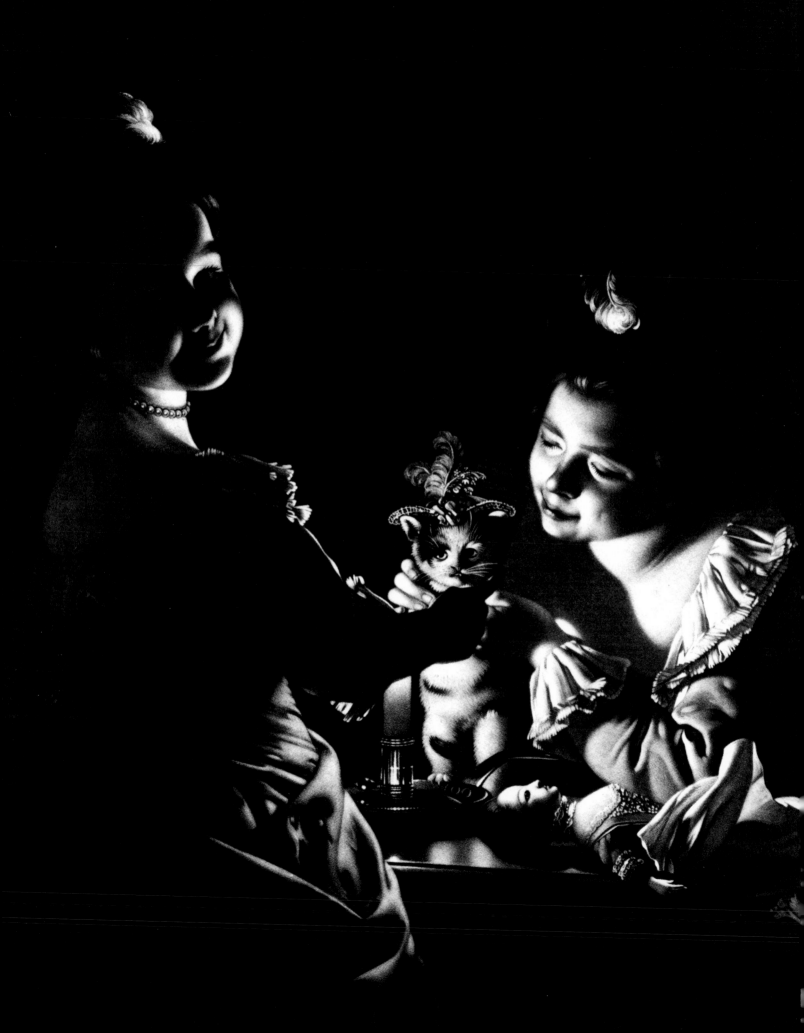

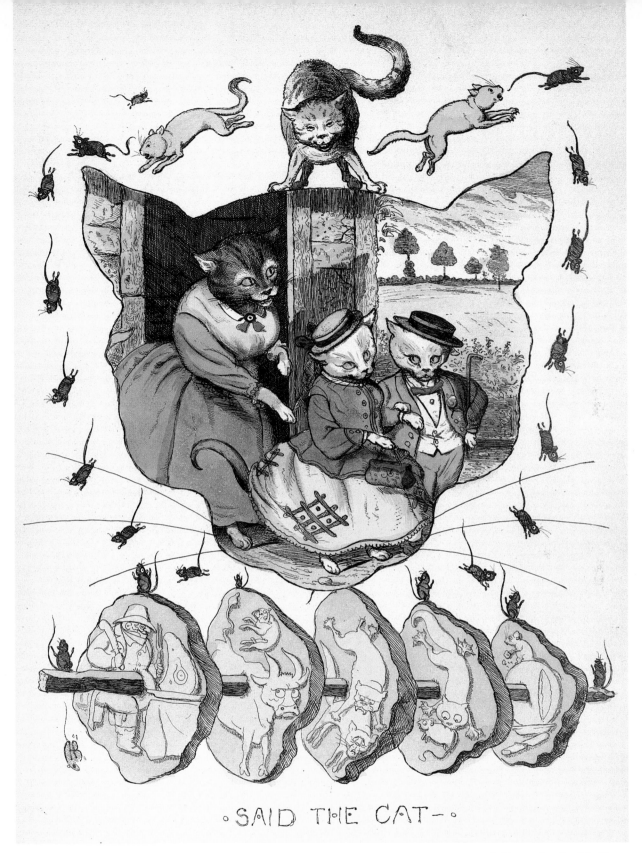

· SAID THE CAT ·

Miss Kitty Dressing. Joseph Wright of Derby (English, 1734–1797) painted this picture, and in 1781 it was engraved by Thomas Watson (1750?–1781). Wright of Derby specialized in painting lighting effects; while he was traveling in Italy, a grandiose fireworks display in Rome and a fiery eruption of Mount Vesuvius interested him more than the Sistine Chapel or the Roman Forum. His candlelight and moonlight paintings show affinities with contemporary Dutch and French artists. In this candlelit scene, two girls borrow the plumed hat from a doll in order to dress up a tolerant kitten.

Said the Cat. From an 1865 children's book, this illustration summarizes a cautionary lesson given by a mother cat to her two kittens. Five skewered pieces of cat's meat show how the mouse gnaws the cheese, the cat catches the mouse, the dog worries the cat, the bullock tosses the dog, and the farmer cuts up the bullock for his Christmas dinner. Charles Henry Bennett (English, 1829–1876) made this drawing for *The Sorrowful Ending of Noodledoo, with the Fortunes and Fate of Her Neighbours and Friends,* and hid his initials in a mouse at lower left.

My Little White Kitties Into Mischief. Of the two white kittens who lap up the milk they have spilled on a parlor table or sideboard, the one at left seems greedier than his companion in crime. A vivid red curtain behind them suggests a Victorian parlor. Perhaps this print, lithographed by Currier & Ives, reflects American economic progress in the mid-nineteenth century, when many cats no longer earned their keep by mousing in barns or cellars, but became "parlorized" members of the household.

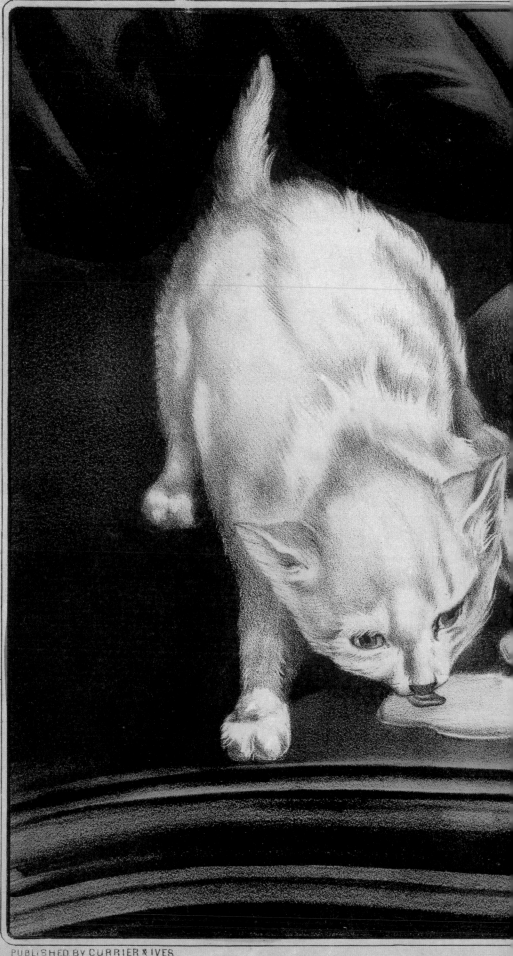

PUBLISHED BY CURRIER & IVES,

MY LIT

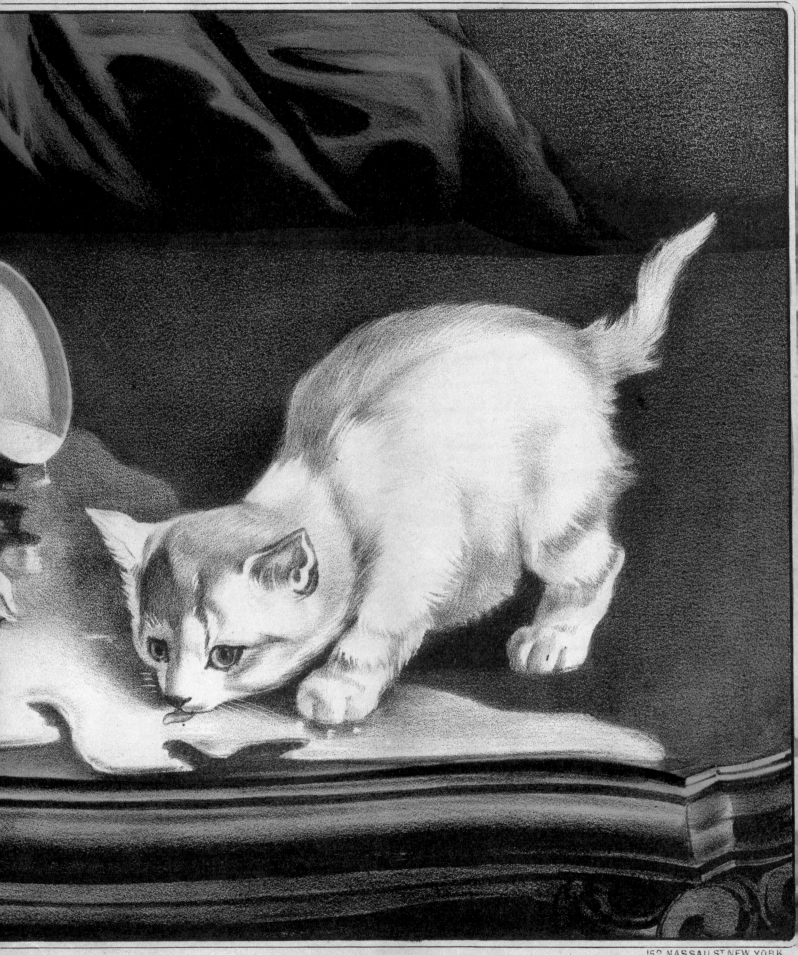

152 NASSAU St NEW YORK.

E WHITE KITTIES.

INTO MISCHIEF.

Two Cats. In the woodcut above, roughly contemporary with the one at left, two cats are about to encounter each other. The tense moment is dramatically emphasized by the pattern of the tile floor and the exaggerated perspective. Such striking black and white designs are a hallmark of Félix Vallotton (1865–1925), a French painter and graphic artist and a member of the Nabis, a Parisian art movement. The modern rejuvenation of the woodcut as a creative medium began with his designs depicting Parisian society with boldness, brio, and satiric wit.

Two Cats. A leader of German Expressionism, the graphic artist and painter Karl Schmidt-Rottluff (1884–1976) executed more than seven hundred engravings, woodcuts, and lithographs. One of the founders of the 1905 art movement *die Brücke* in Dresden, he later was much influenced by both Cubism and African art, as this woodcut of two cats shows.

OVERLEAF. **Harper's July.** This poster by Edward Penfield (American, 1866–1925) advertises a July issue of *Harper's Magazine* of 1898. Two cats face each other in a highly stylized decorative scheme, the potted plant between them making both animals appear to be enormous—the cats distinctly resemble cows. Cats have always been popular in America, and *Harper's* at that time was a very popular magazine. Founded in New York in 1850, it was fully illustrated, carried serial installments of English novels, and achieved a wide readership in the years after the Civil War.

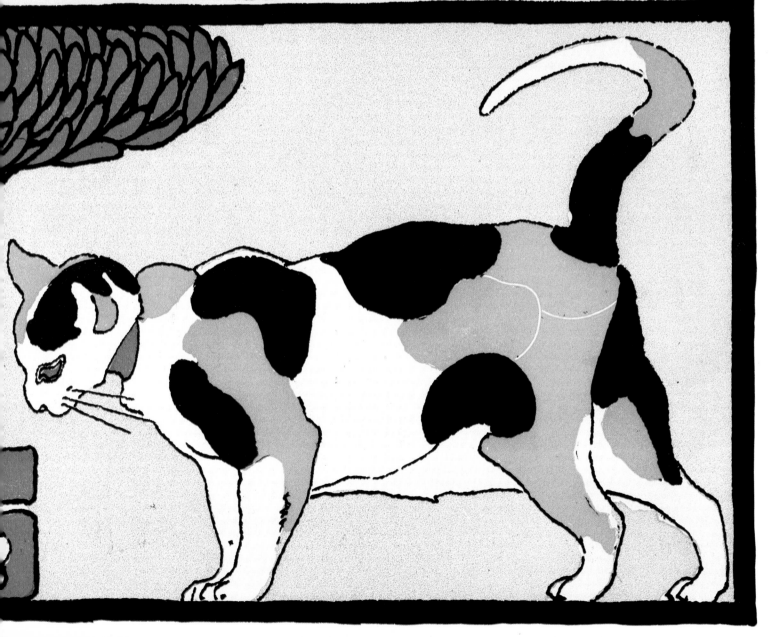

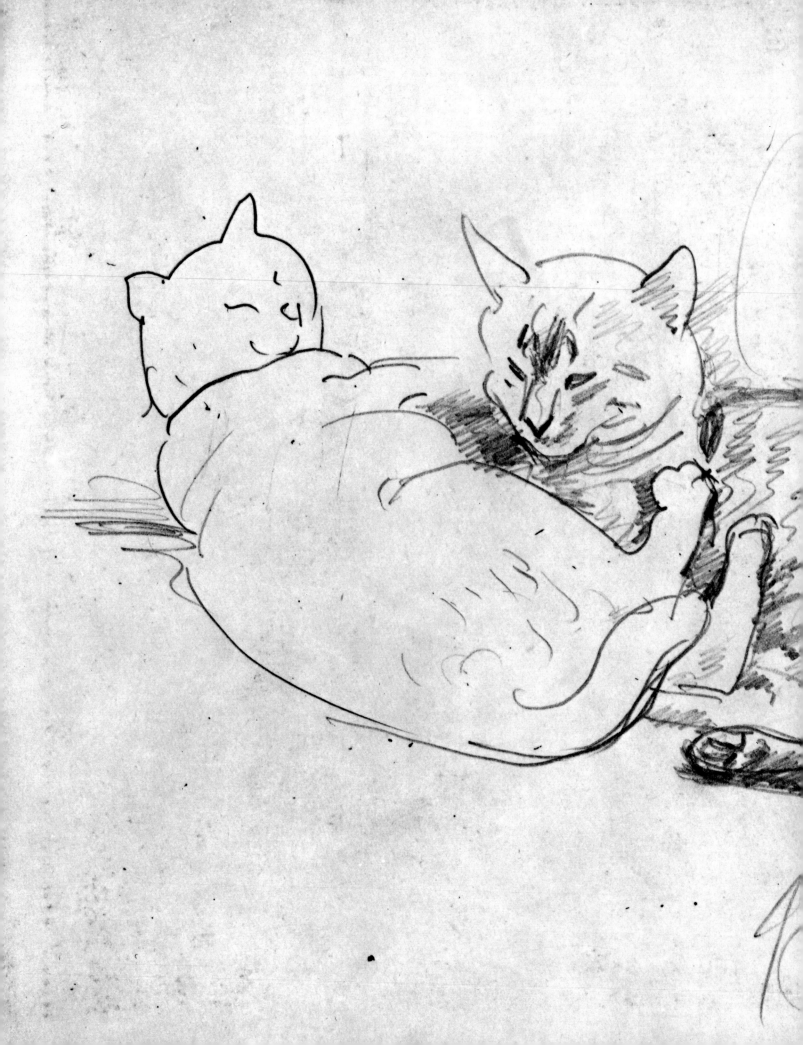

Cats at Play. In a light moment and in a gentle vein, the virtuoso American portrait painter John Singer Sargent (1856–1925) drew this delicate and amusing pencil sketch of two cats lying together and playing in an easy chair. Sargent, born in Italy of expatriate parents, settled in London, where he became painter to high society during the Edwardian and Georgian eras, continuing the bravura tradition of Sir Thomas Lawrence and rivaling the well-known contemporary Italian portraitist Giovanni Boldini for technical brilliance.

That this simple study so quickly done, so subtly observed, and so lacking in showy technique could have been executed by the same artist whose flamboyant style distinguishes his *Portrait of Madame X (Madame Gautreau)* is amazing even in our age, when amazement is almost anachronistic.

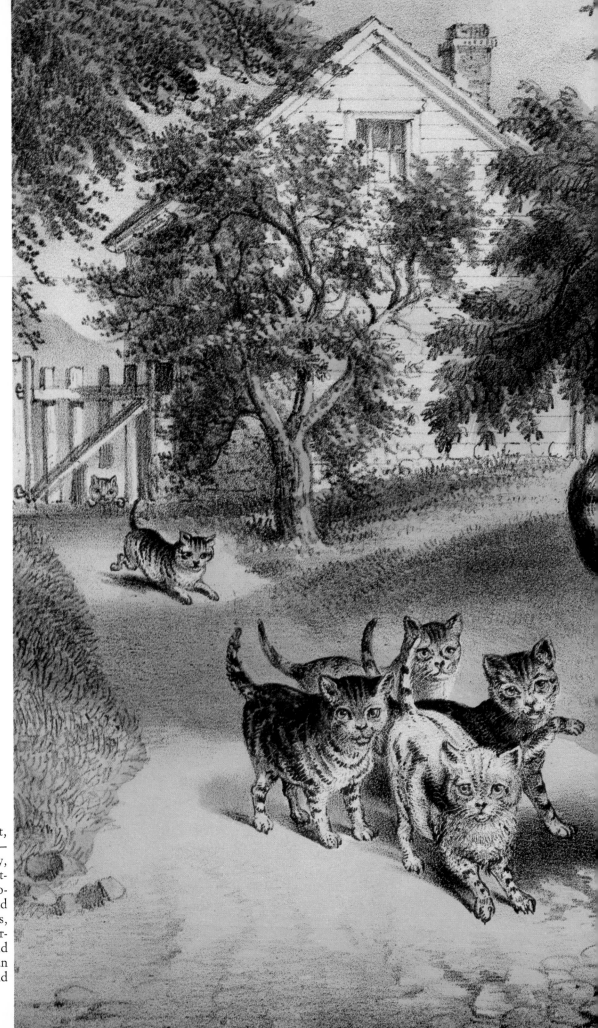

Pussy's Return. A mother cat, followed by her six kittens—all of which are, unrealistically, gray—returns from a walk outside the family yard. Lithographed by Currier & Ives and hand colored in pastel shades, this print both idealizes motherhood, childhood, home, and hearth, and bespeaks an urban dream of house, garden, and leafy, rose-covered bower.

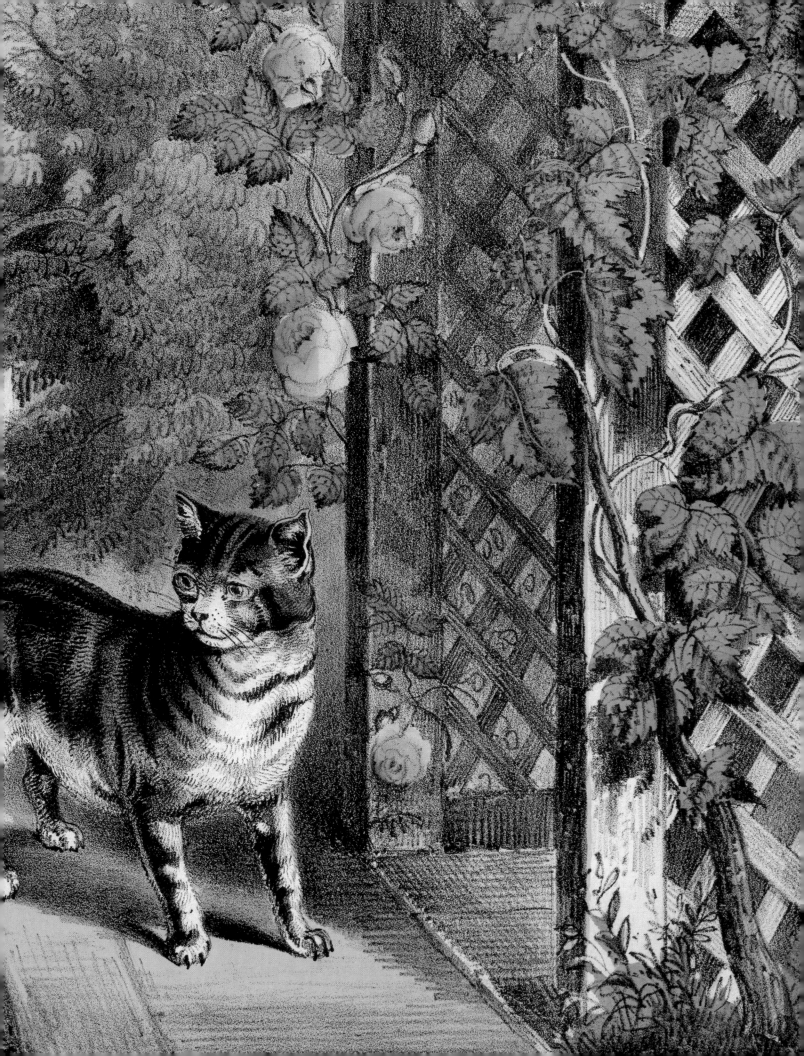

Ut timore de manu:

inimicorum nostrorum

liberati serviamus illi

In sanctitate et iusti

cia coram ipso omnibz di

ebz nris

Et tu puer: propheta al

tissimi uocaberis preibis

enim ante faciem domi

ni parare uias eius.

Ad dandam scienciam

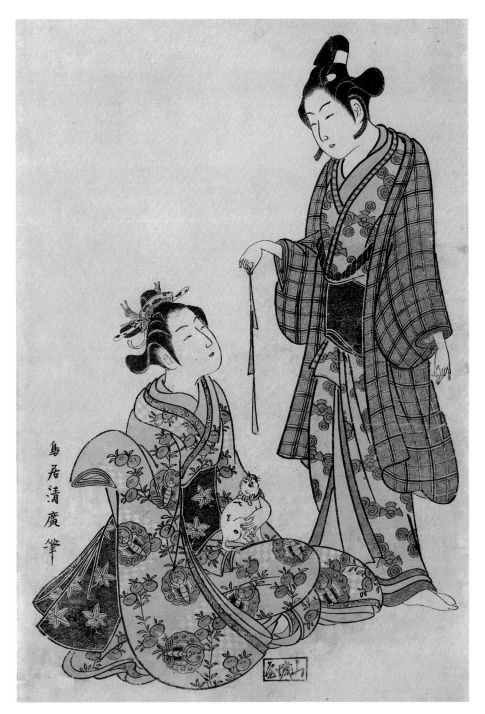

Woman, Man, and Cat. The cat in this wood-block print, made about 1755 by Torii Kiyohiro (Japanese, active c. 1737–1766), is held by a seated woman while a man dangles silk or paper above its head. True of this scene is a *bon mot* of Montaigne: "When I play with my cat, who knows whether she isn't amusing herself with me more than I am with her?"

Drôlerie. Jean Pucelle (French, fl. c. 1324–1327) illuminated devotional books, often with fanciful marginal designs called *drôleries* that were playful in subject but often had deeper meanings. This scene, from the small (3½ x 2½ in.) prayerbook called the *Book of Hours of Jeanne d'Evreux,* which he created in 1325–28 for the queen of France, shows a figure shrouded in a robe, seated on a bearded head, and spinning wool onto a distaff. Four lines below, a great cat has caught the ball of wool.

Don Manuel Osorio Manrique de Zuñiga. One of the greatest of all Spanish artists, Francisco José de Goya y Lucientes (1746–1828) painted this portrait of a young nobleman, son of the thirteenth count of Altamira, about 1786–1789 when the boy was very young. Don Manuel stands between a cage filled with little birds and a trio of cats; behind him, a luminous but undefined background shades into darkness, from which the cats glower at a magpie that the child holds on a leash. Goya has signed his name on the card in its beak. The tortoiseshell cat in the foreground is intent upon the bird, the gray-striped cat recedes into the background, and of the third cat little is left but the stare.

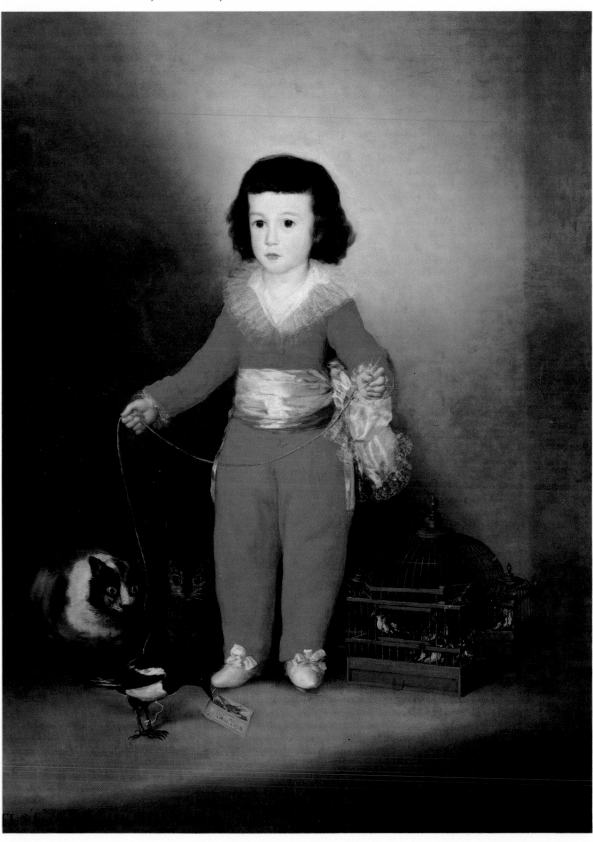

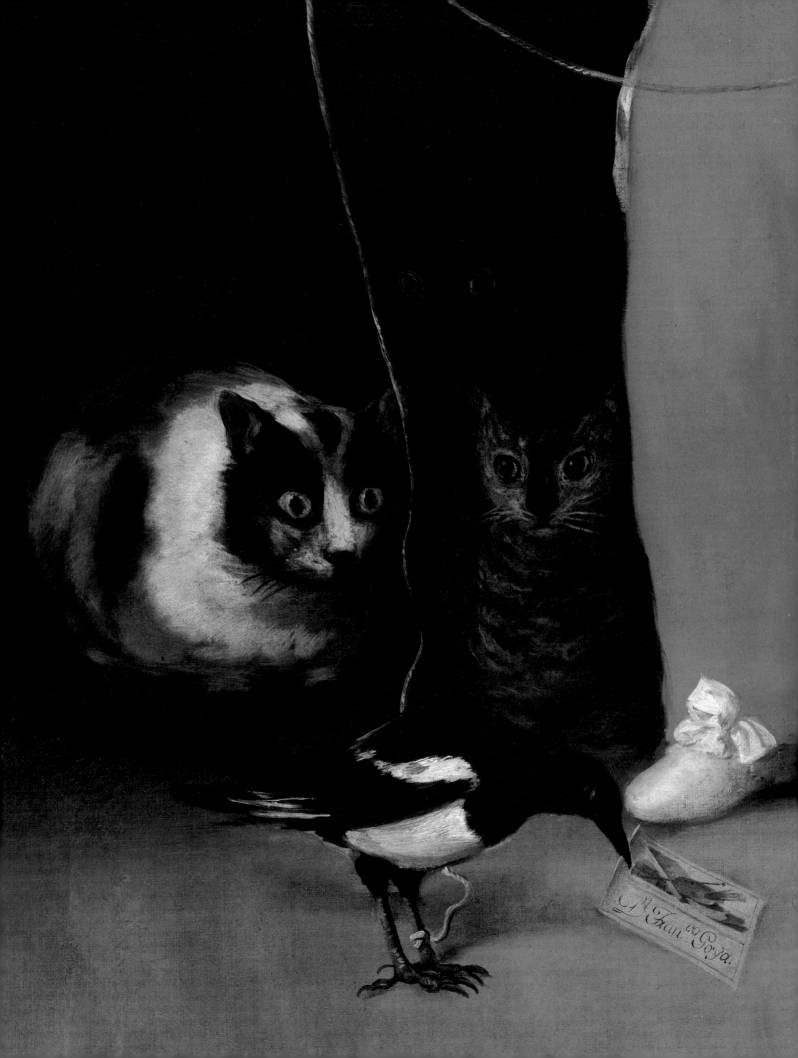

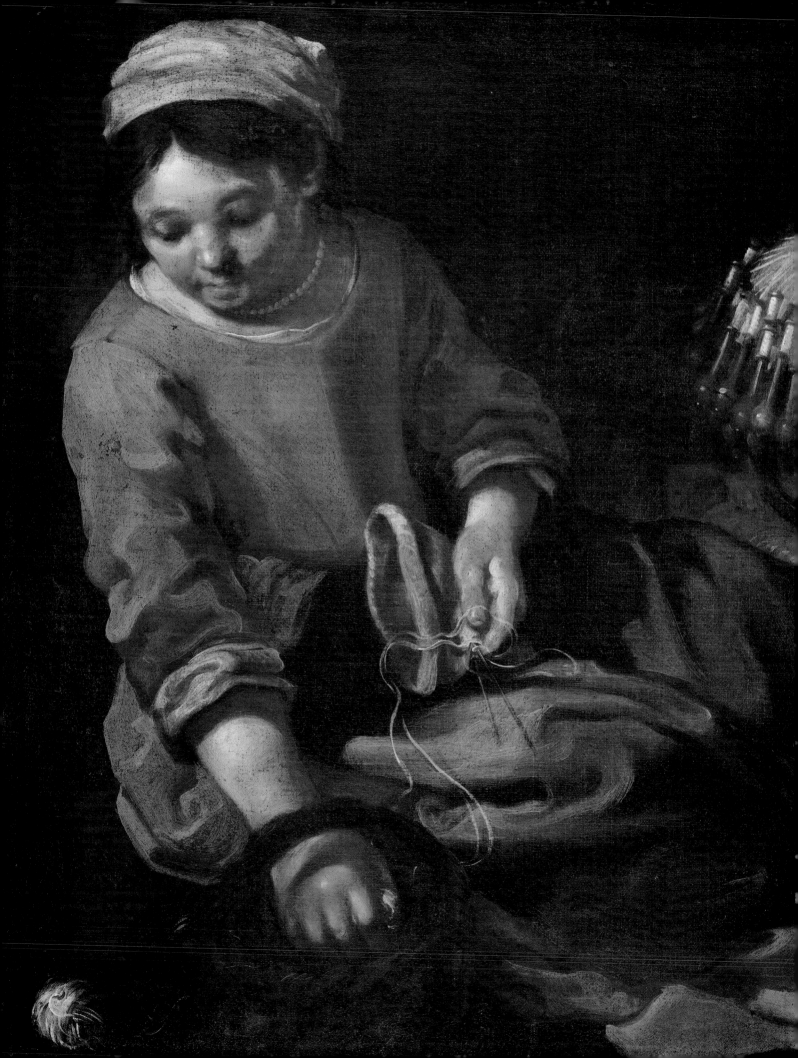

The Lacemaker. This painting seems mistitled because the girl pictured is knitting, not making lace. The lace pillow on the chair calls attention to the absence of its artisan. But perhaps the knitter has abandoned the more strenuous task for a simpler one. During his stay in Rome, which lasted from 1655 until his death, Bernard Keil (Danish, 1624–1687) painted three pictures of sewing schools that display their hierarchy of functions: embroiderers and lacemakers are at the top level of skill, and knitters are toward the bottom.

The girl has just dropped a ball of yarn that catches the eye of the cat, perhaps a symbol of idle mischief in counterpoise to so much industrious handiwork. Which of the two will retrieve it first?

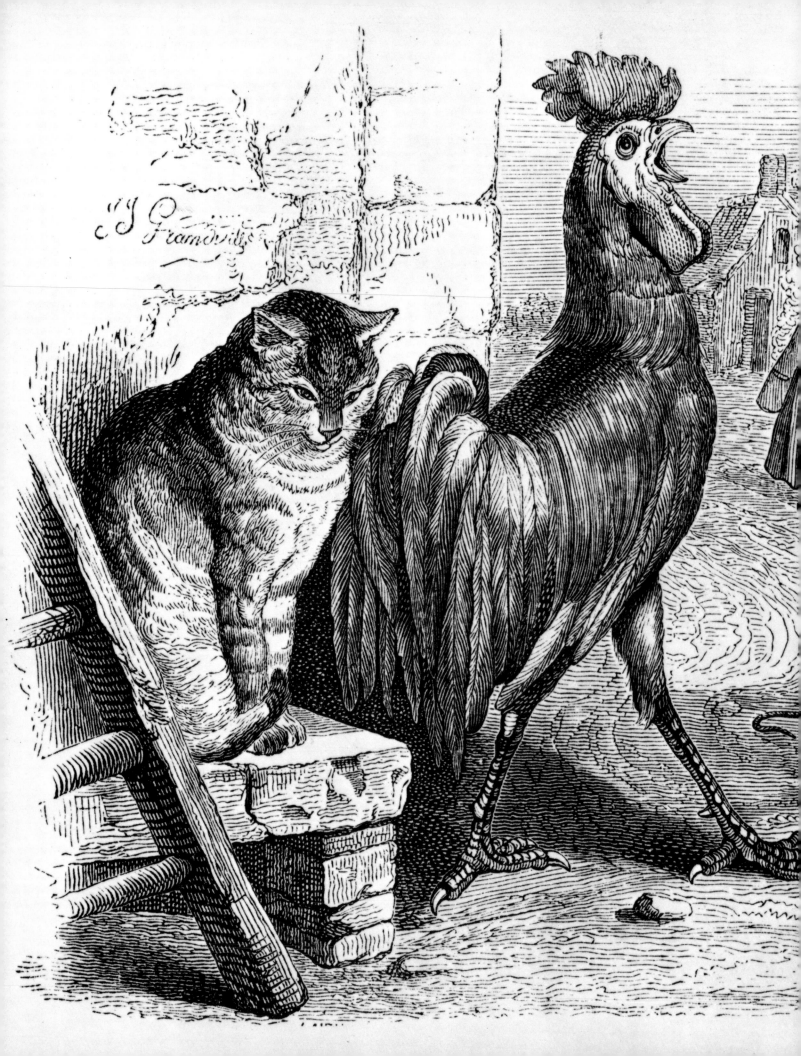

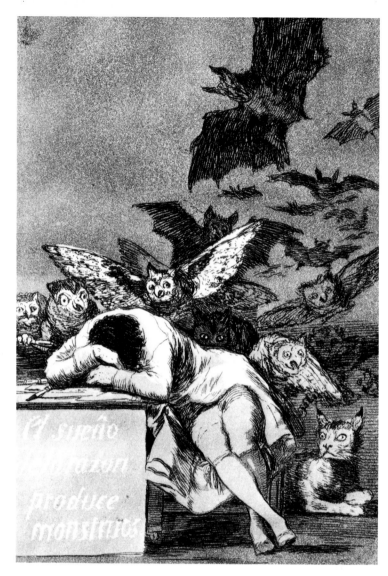

El Sueño de la Razón Produce Monstruos ("The Sleep of Reason Breeds Monsters"). This eerie scene is No. 43 of *Los Caprichos*—"Caprices"—a set of eighty phantasmagoric etchings with aquatints published in 1799 by Francisco José de Goya y Lucientes (1746–1828). Goya describes the print: "Imagination, deserted by reason, begets impossible monsters. United with reason, she is the mother of all arts, and the source of their wonders." His use of cats and catlike features as symbols of dark and terrifying evils harks back to the Middle Ages, when in some parts of Europe cats were thought of as witches' familiars and, as their alter egos, were subject to hideous persecution.

The Cock, the Cat, and the Little Rat. J. J. Grandville—pseudonym of J. I. I. Gérard (French, 1803–1847)—used animals to tell truths about humans. This engraving from his illustrated edition of La Fontaine's *Fables,* published in Paris in 1839, accompanies the fable of a young rat's entry into the great world, where he is deceived into believing that the restless, wild, and turbulent cock is an enemy, the gentle, tender, and mild cat a friend. The moral is: "Take care, my child, in any case,/Judge no one by their look or face." Grandville's pussycat is every bit as placid as La Fontaine's description could require.

The Silver Tureen. The dashing brushwork and baroque feeling of this painting by Jean-Baptiste Siméon Chardin (French, 1699–1779) are an example of his early style, developed before the 1730s. Chardin, who later lived in the Louvre, gave this painting to his friend, the engraver Le Bas, in exchange for a vest.

The silvery covered vessel is a special type of stew pot called a *pot-à-oille.* With the game that might be stewed in it, it sits in a stone larder niche. At the lower left crouches a cat who predatorily eyes the dead partridge above its head.

The warm and burnished tones of Flemish still life and the visual delight in contrasting textures of plumage and fur are carried over from seventeenth-century art into this spacious and spontaneous painting. But the living cat, in readiness to pounce, makes the scene something more than a still life.

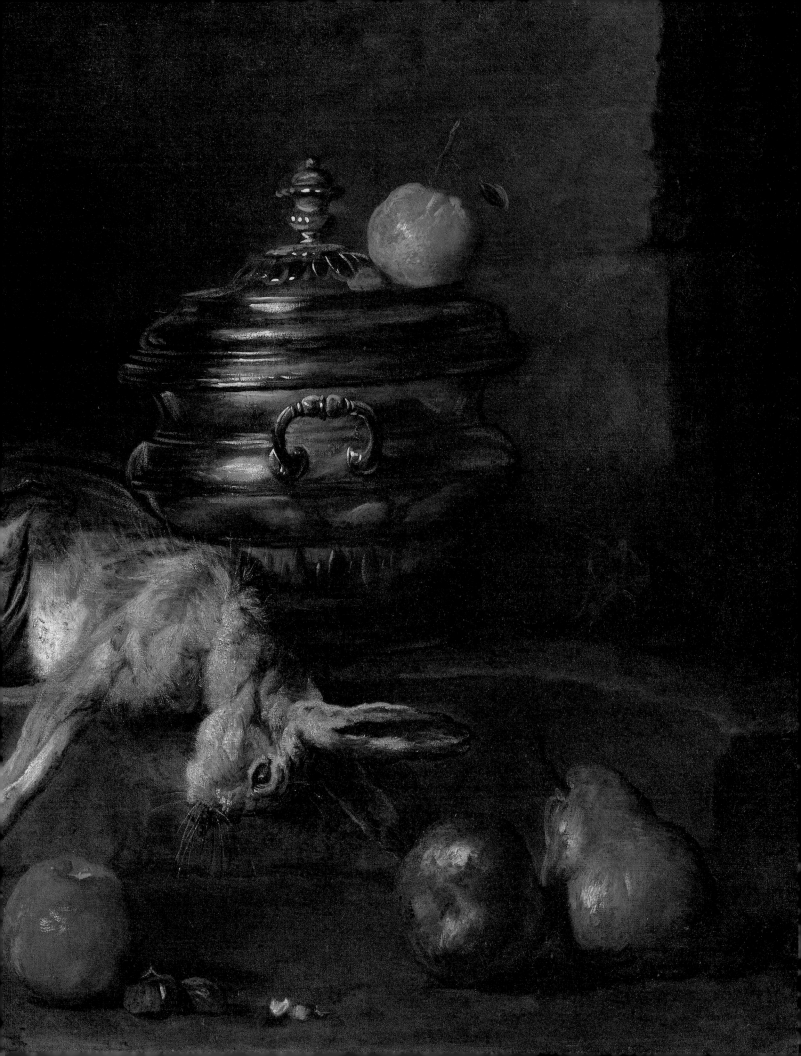

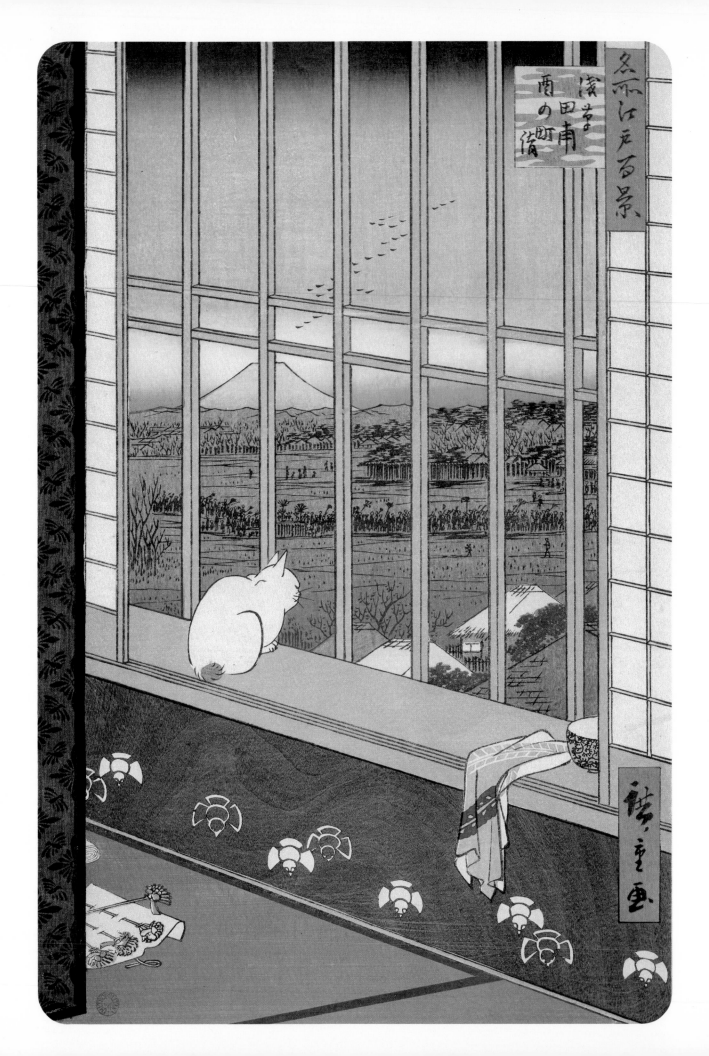

Cat in Window. This delicately colored wood-block print was made by one of the greatest of all Japanese printmakers, Andō Hiroshige (1797–1858). He and the printmaker Katsushika Hokusai, both ukiyo-e artists, applied the technique of printing with color blocks to depicting landscape, especially scenes from the regions neighboring Edo (now Tokyo) or views along the Tokaidō, the old high road from Edo to Kyoto. In the print, from the series *Famous Sites of Edo: One Hundred Views,* a fat white cat looks out from a window in Asakusa at a vast landscape and a holiday crowd returning from the Tori no Machi festival. The cone of Mount Fuji gleams in the distance.

Little Gray Cat. By the American painter and sculptor Elizabeth Norton (1887–?), this woodcut is bordered by everything a cat likes best. But the long-haired cat ignores the bowls of cream set out for it below to gaze longingly at the enticing birds above.

The Watchful Cat. The arched head and coiled tail of this cat do not seem to indicate that he is about to spring on some prey, but rather that he is playfully regarding something in motion. John Alonzo Williams (American, 1869–1947) created the tabby cat with great free strokes of watercolor, capturing the velvety fur.

OVERLEAF. **Spring Play in a T'ang Garden,** detail. See description, p. 14

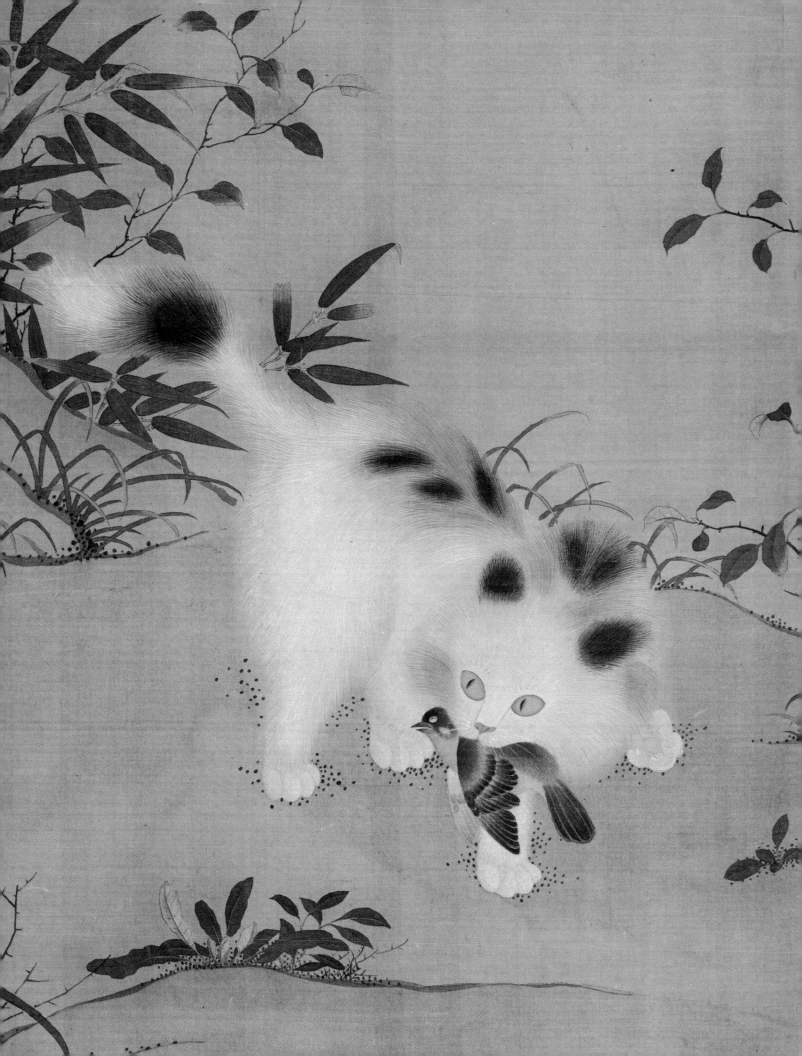

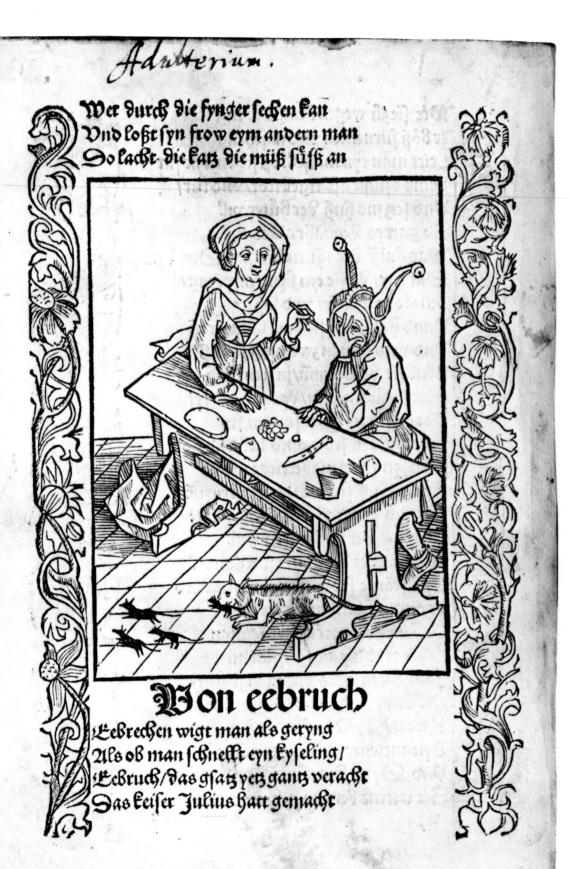

Adulterium.

Wer durch die fynger sechen kan
Vnd loßt syn frow eym andern man
So lacht die katz die müß süß an

Von eebruch

Eebrechen wigt man als geryng
Als ob man schnellt eyn kyseling/
Eebruch/das gsatz yetz gantz veracht
Das keiser Julius hatt gemacht

Of Adultery. By an unknown artist, this woodcut is from *Das Narrenschiff* ("The Ship of Fools") by Sebastian Brant (German, 1454–1521), published in Basel in 1494. The wife tickles her foolish husband's nose with a reed—in other words, lulls him off guard by flattery. A cat chases mice through the scene, representing the wife who enjoys adultery as much as the cat enjoys mousing. The lines above and below the plate read: "If through his fingers one can see/ And lets his wife promiscuous be,/ As cat she views the mice with glee." "Adultery's called a trifling thing,/ Like casting pebbles from a sling,/ Adultery now pays no heed/ To laws that Julius once decreed."

Cat and Spider. Toko, a Japanese artist of the Meiji period (1868–1911), painted this Siamese cat on silk, using colors and washes in his ink drawing. The cat regards a spider that is moving away as fast as it can. In southern Japan, spiders outnumber people eighty-six to one, and many cats are spider hunters, tracking down those pests that invade homes. Toko calls attention to the similarities between the cat's whiskers and the spider's legs.

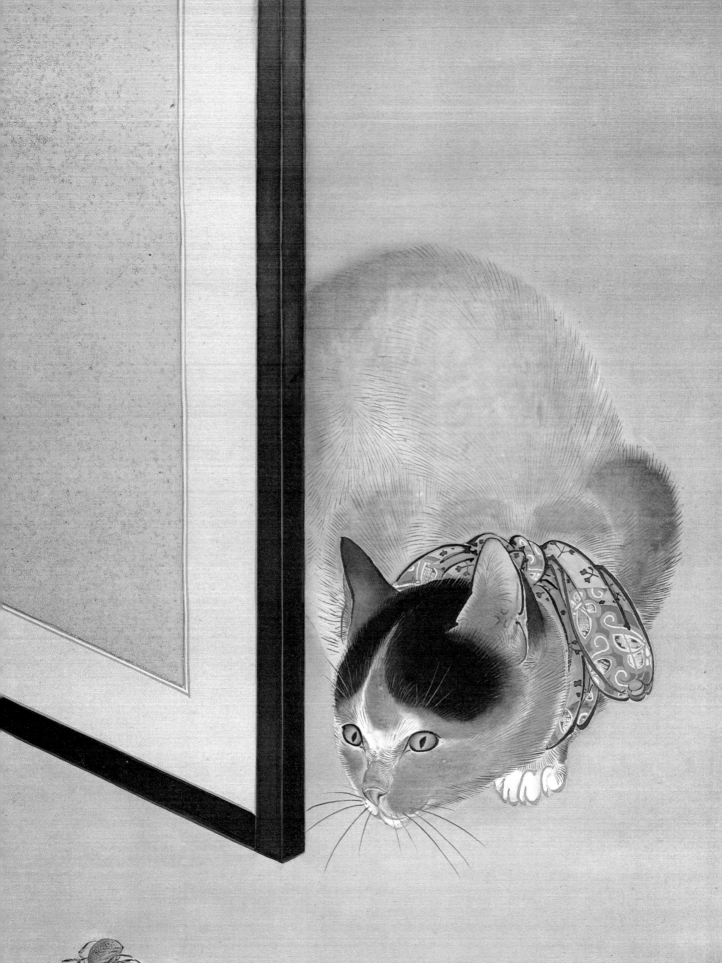

A Cat and a Cock. In 1931 Alexander Calder (American, 1898–1976) illustrated the limited edition of *Fables of Aesop* in which this image is found. Calder's bold, original draftsmanship had evolved a few years earlier. "I seemed to have the knack of doing it with a single line," he noted. His rapid, shorthand technique here captures the essential characteristics of both cat and cock as well as the force and movement of their sudden encounter.

The Cat and Cock. Francis Barlow (English, 1626?–1702) made this illustration for *Aesop's Fables with His Life,* first published in London in 1666. Birds twitter about the eaves of the barn as a long-legged, long-tailed, long-eared cat—one that much resembles a fox—jumps the cock. The landscape behind the thatched cottage may be based on a view of the Cotswolds.

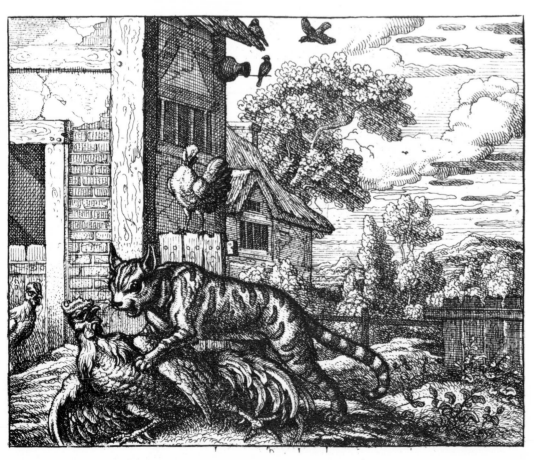

The Cat and Cock. 115

A CAT

AND A COCK

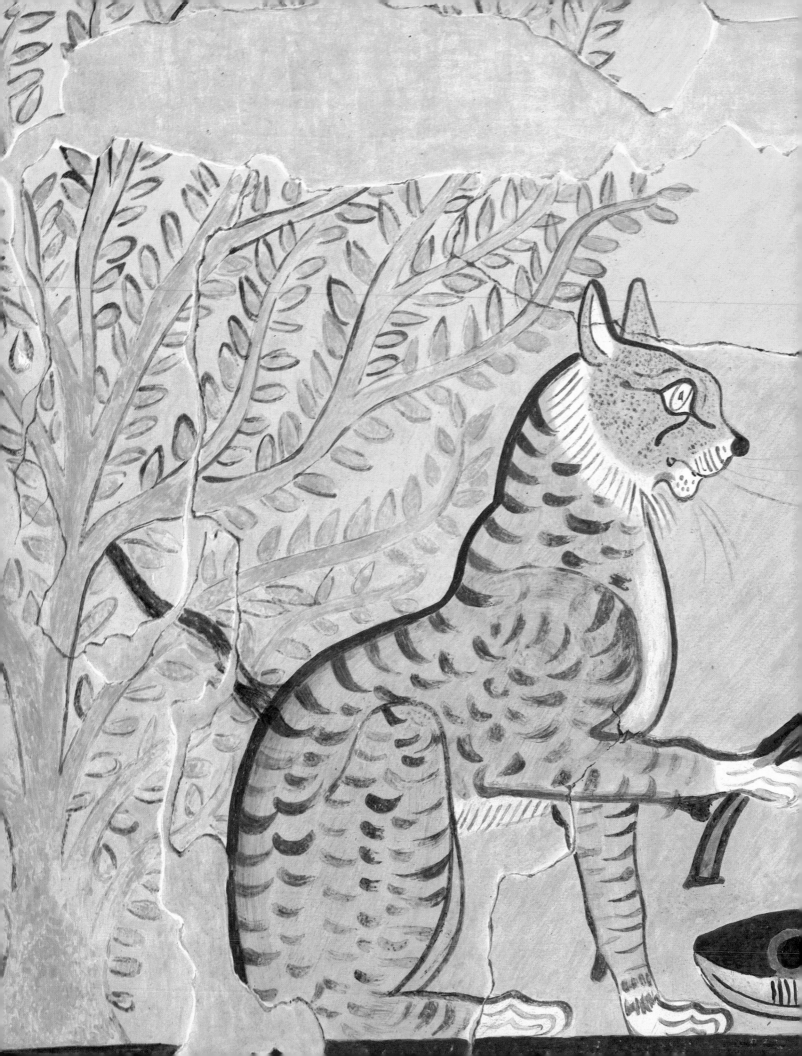

Cat and Serpent. This painting of the cat as a deity belongs to the Metropolitan Museum's collection of facsimiles of wall frescoes from Egyptian tombs (see p. 24).

The Egyptian sun god Ra in the form of a grayish yellow cat raises a knife to lop off the head of Apophis, god of darkness and chaos, shown as a serpent. The original of this painting adorns a doorjamb of the subterranean burial chamber in the Tomb of Sennedjem at Deir el Medina and was painted about 1300 B.C.

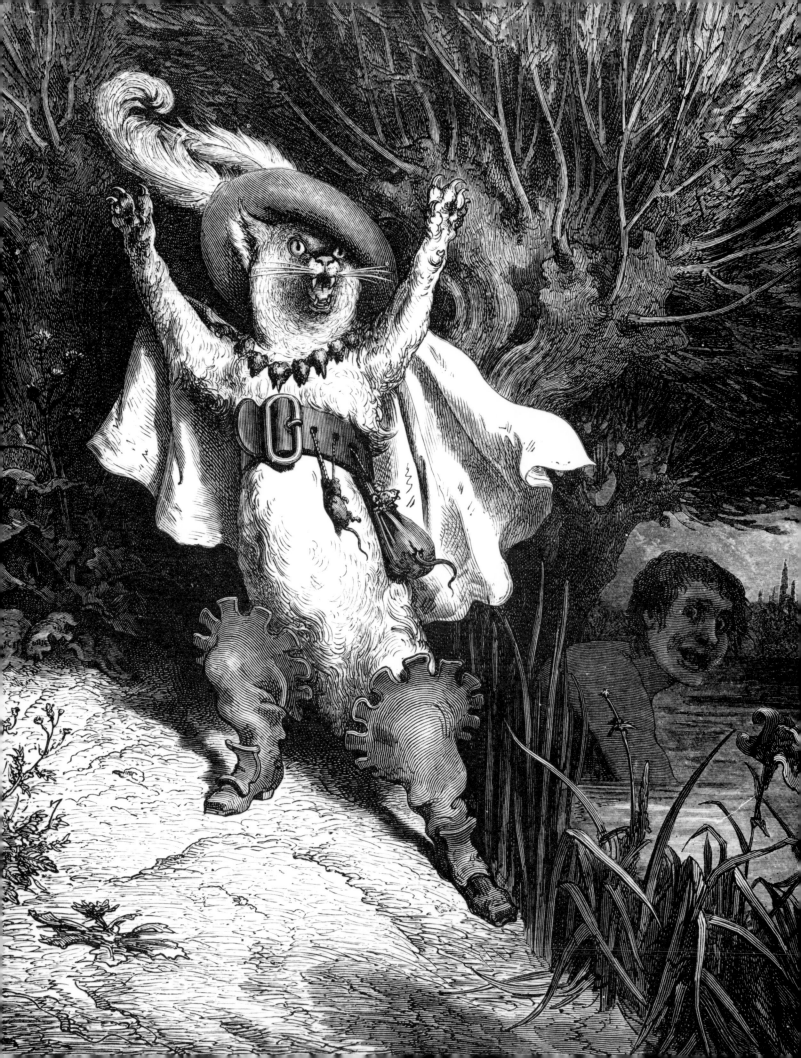

Puss in Boots. Gustave Doré (French, 1832–1883), one of the most important illustrators of the nineteenth century, is noted for the highly dramatic and imaginative engravings that he made for more than 120 books, including lively illustrations for Dante's *Divine Comedy,* Milton's *Paradise Lost,* and Balzac's *Droll Stories.* Doré also illustrated several collections of tales and fables, including La Fontaine's *Fables* and Charles Perrault's fairy tales. Perrault's 1697 landmark, *Histoires ou contes du temps passé,* was a collection of eight fairy tales that gave classic form to such traditional stories as that of Bluebeard, Sleeping Beauty, and Puss in Boots.

This magnificent Puss in Boots was engraved by Doré to illustrate an 1862 edition of Perrault's tales. The intrepid cat calls for help while his master silently crouches in the water, awaiting rescue. The cat's fabled boots go halfway up his thighs and perfectly match his monumental leather belt, operatic cloak, and distinctively plumed hat. From his belt dangle two mice, one encased in a bag, both intended for future snacks.

Cat and Fishbowl. Théophile-Alexandre Steinlen (French, 1859–1923) drew the cat here in quite a different style from those shown on pages 10–11 and 31. The unfortunate Selima in "Ode on the Death of a Favourite Cat Drowned in a Tub of Gold Fishes" by Thomas Gray (1716–1771) felt the same attraction as this cat: "The hapless Nymph with wonder saw:/A whisker first and then a claw,/With many an ardent wish,/She stretch'd in vain to reach the prize./What female heart can gold despise?/What Cat's averse to fish?"

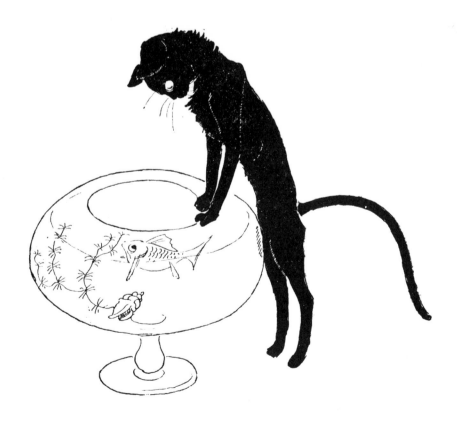

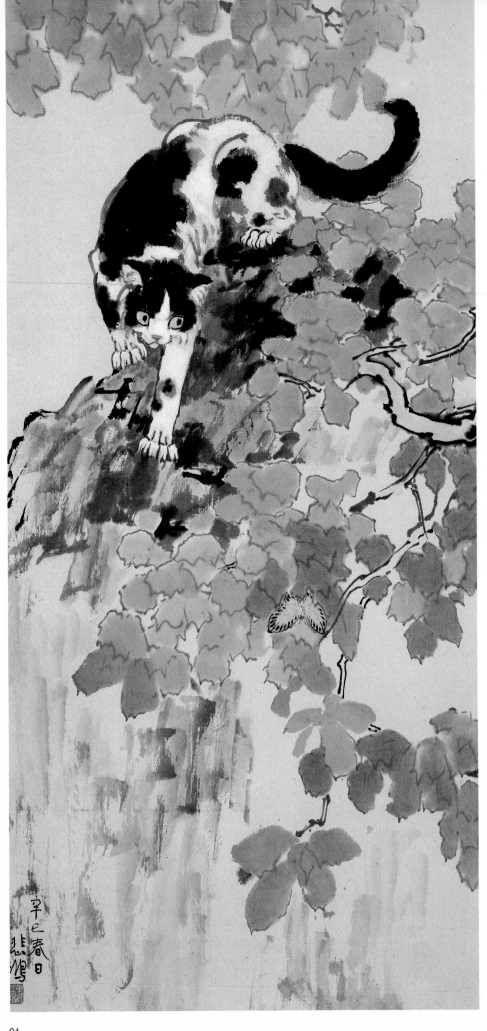

Cat and Yellow Butterfly. Cats did not appear in Chinese art until the Sung dynasty (A.D. 960–1279), more than two thousand years later than in Indian art. Perhaps the cat lacked popularity in early China due to the legend that it was the only creature that did not mourn the death of Buddha. In Sung dynasty art, cats were commonly shown with aristocratic children; later, they appeared alone, on fantastic rocks in gardens. Although they might chase butterflies, they are almost never shown in the more predatory role of mousing. This early twentieth-century hanging scroll was painted in ink and color on paper by Hsü Pei-hung (Chinese, 1895–1953), also known as Ju Péon. The stealthy cat gives a downward glide and tension to the entire composition.

Cat and Frog. The ukiyo-e artist Kawanabe Gyōsai (Japanese, 1831–1889) executed this painting on silk. The ferocious cat resembles a tiger more than a family pet. Lunging toward the viewer, it only incidentally places one paw on the terrified frog, which must regret having hopped onto dry land. The cat's golden eyes emphasize its predatory nature.

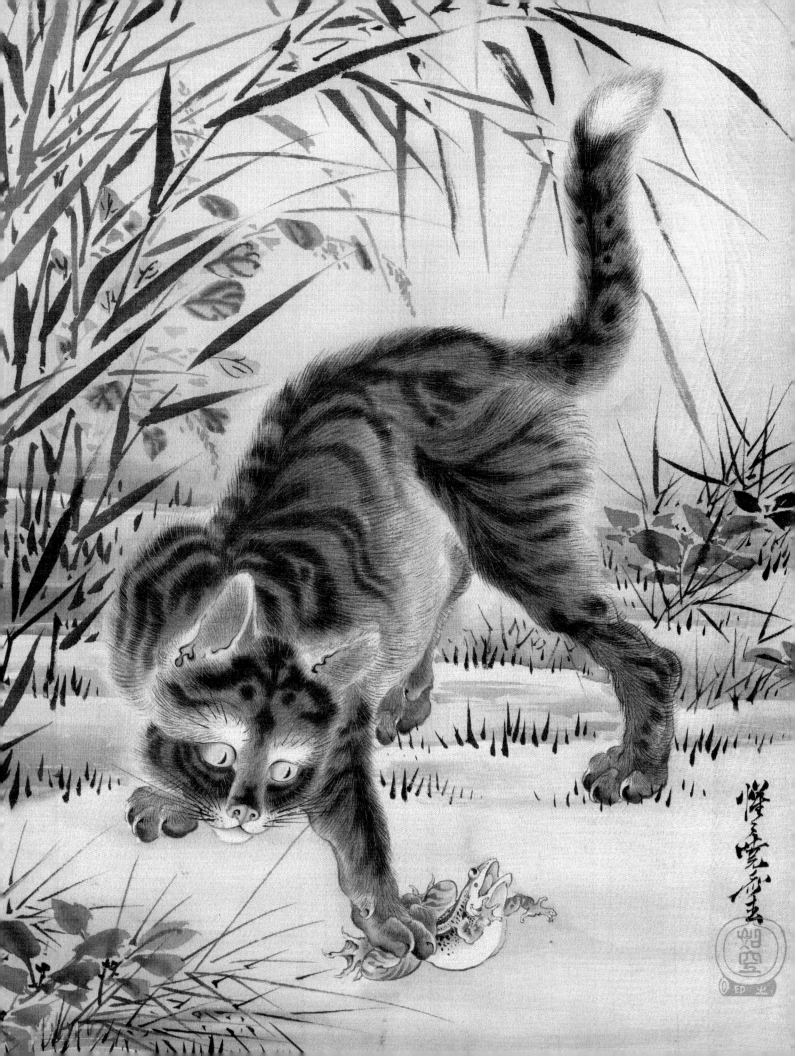

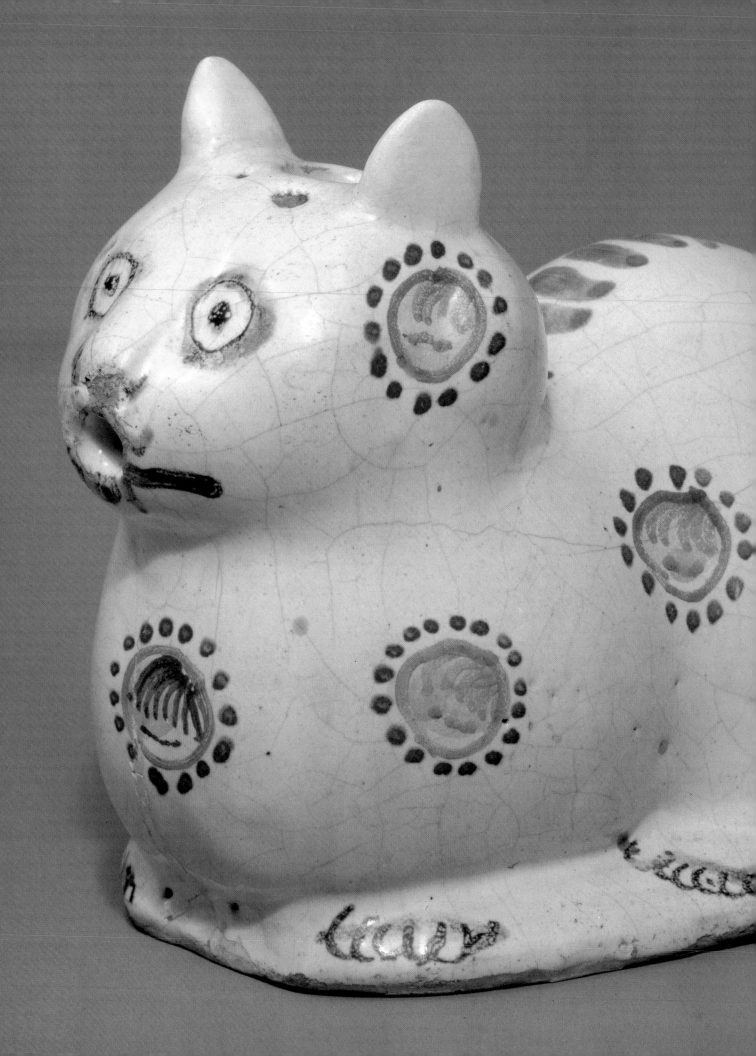

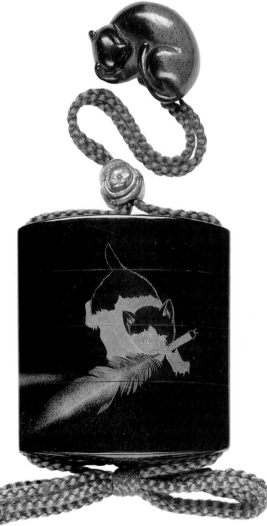

Ceramic Cat. Made in Lambeth, just across the River Thames from London, about 1650, this fine Old English cat is of tin-enameled earthenware. When filled with hot liquid, its plump form became a comfortable hand warmer.

Inrō with Netsuke. Sekigawa Katsunobu, a Japanese lacquer artist, active about the mid-nineteenth century, made the remarkable *inrō* pictured here. Using color with great delicacy, especially in the kitten's face and in the feather, the artist has made a design very like a painting. The blue of the lower feather is a color rare in lacquer ware. The netsuke, a sleeping cat, is carved from wood. From the Charles A. Greenfield Collection, this set was exhibited at the Metropolitan Museum in 1980.

Dutch Tile. Delftware ceramics were decorated with a wide variety of subjects—people, village scenes, flowers, and animals. This cat, which somewhat resembles a monkey, appears on one of twenty-four tiles made in Delft, Holland, between 1650 and 1700, and assembled into a panel.

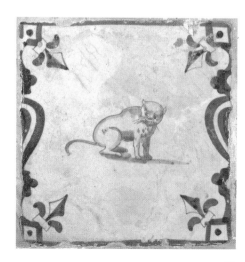

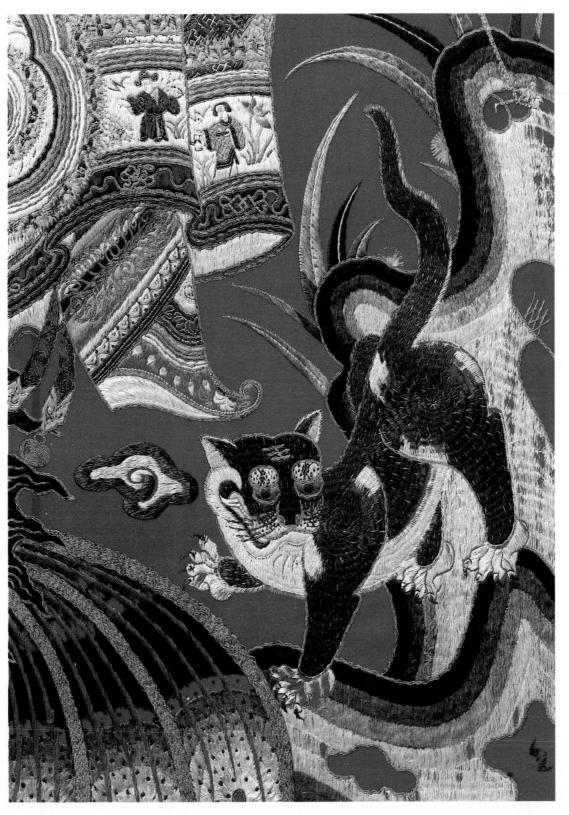

Manchu Cat. With the mark of nobility upon its forehead and with its four magnificently flaring paws, this prancing cat is a fit companion for the other gaudy and sumptuous personages of Chinese opera on a Ch'ing dynasty theater curtain made in Peking about 1821–50. The red wool flannel backdrop is embroidered in many shades of silk.

Cat from the Caswell Carpet. A blue and white feline of steadfast gaze decorates one of eighteen squares that make up the extraordinary early American embroidered rug called the Caswell Carpet. It was stitched between 1832 and 1835 by Zeruah Higley Guernsey, later Mrs. Memri Caswell, as a young woman in Castleton, Vermont.

Its woolen cloth and home-dyed yarns came from Zeruah's own sheep. She performed every step in its manufacture, working figures of a man and woman, puppies and kittens, flowers and birds on a tambour or other frame. The carpet's design, naïve in some respects but not unsophisticated, reminds one of old Persian paintings.

Mrs. Caswell often told how the family cat, walking one day in the parlor, came upon this cat glaring forth so steadily from the rug. The live cat paused, glowered, arched its back, and spat viciously at its embroidered rival.

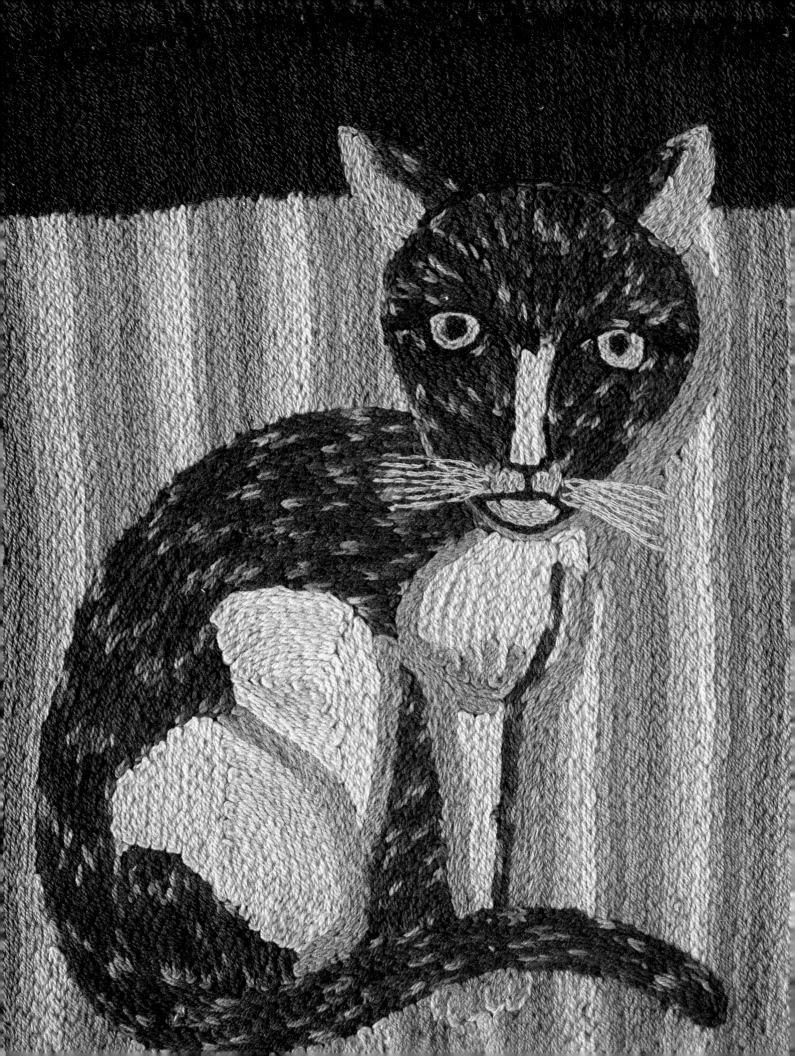

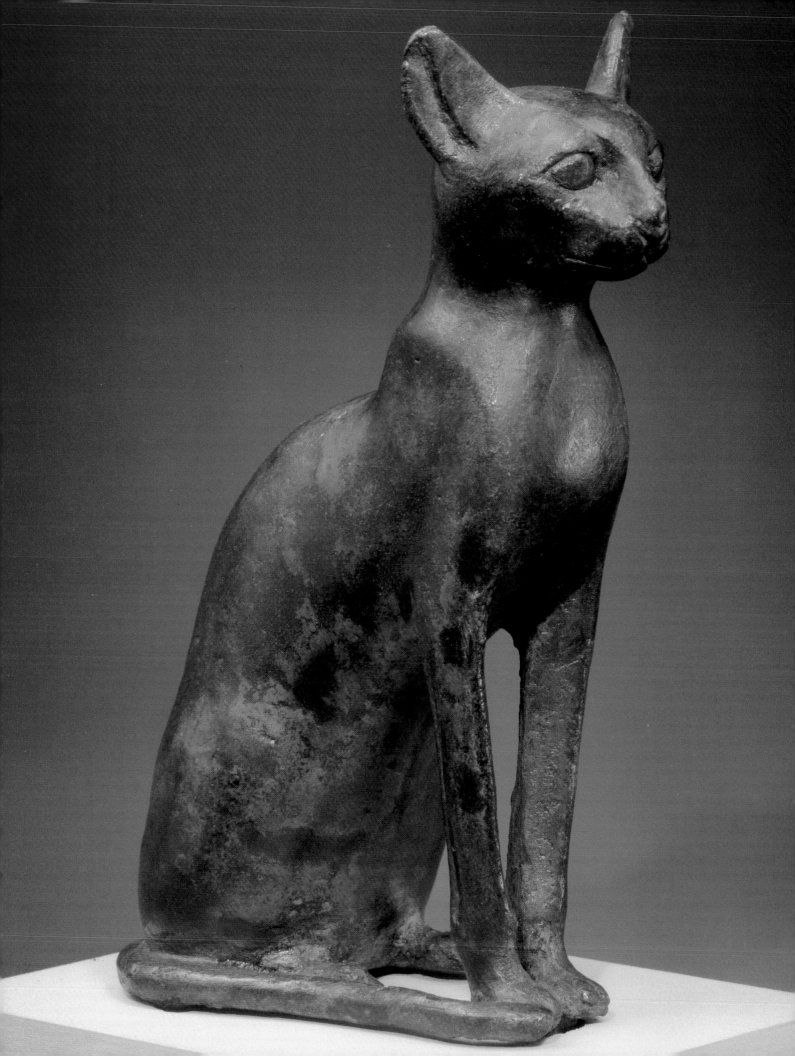

Egyptian Cat. When the capital of Egypt was moved to Bubastis in the Nile delta, about 950 B.C., the cat had been a favorite Egyptian pet for more than a thousand years. As the incarnation of Bastet, patroness of love and joy, cats attained the rank of sacred animals, and were mummified and buried in special cat cemeteries. In her temples, figures of cats were presented as offerings to the goddess. The Egyptian cat *(Felis libyca bubastis)* was a long, lean animal whose head was small in proportion to its body but larger than that of the modern house cat. This small bronze figure of a seated cat dates from the Late Dynastic period (950–350 B.C.).

Ceramic Cats. These cats were made in Staffordshire, England, about 1750, to adorn mantels, bric-a-brac tables, and shelves. The larger cat, of lead-glazed earthenware, seems slightly stodgy besides its variegated companion with its agateware zebra stripes. One can imagine that these wary cats will shortly be fighting, like those in an anonymous poem, "The Kilkenny Cats": "There wanst was two cats in Kilkenny./Each thought there was one cat too many./So they quarrel'd and fit,/They scratched and they bit,/Till, excepting their nails,/And the tips of their tails,/Instead of two cats, there warnt any."

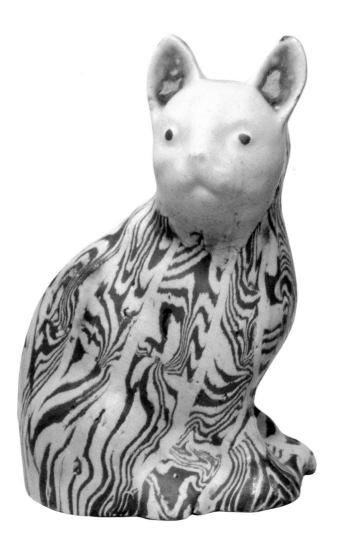

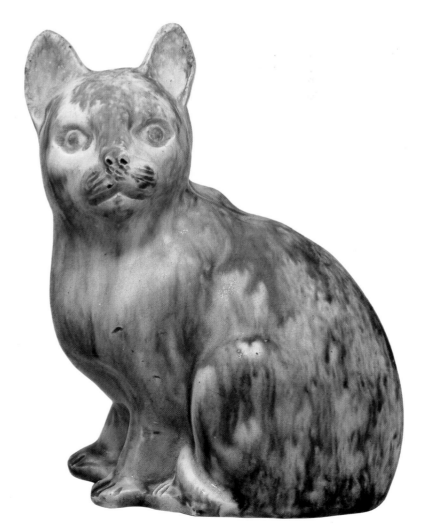

The Cock, the Cat, and the Little Rat. The animals of La Fontaine's fable appear on the tapestry upholstery of this Louis XV armchair, one of a set of eight plus sofa made about the mid-eighteenth century, perhaps at the French manufactory of Aubusson. Other chairs in the set illustrate other tales of La Fontaine and of Aesop. This fable is retold on page 79.

Lacquer Writing Box. A courtesan, a black cat, and two butterflies decorate the lid of this early nineteenth-century box from the Charles A. Greenfield Collection, exhibited at the Metropolitan Museum in 1980. The artist was trying to imitate in lacquer the appearance of a wood-block print; he has outlined the figure of the courtesan in black and used many colors in her robe.

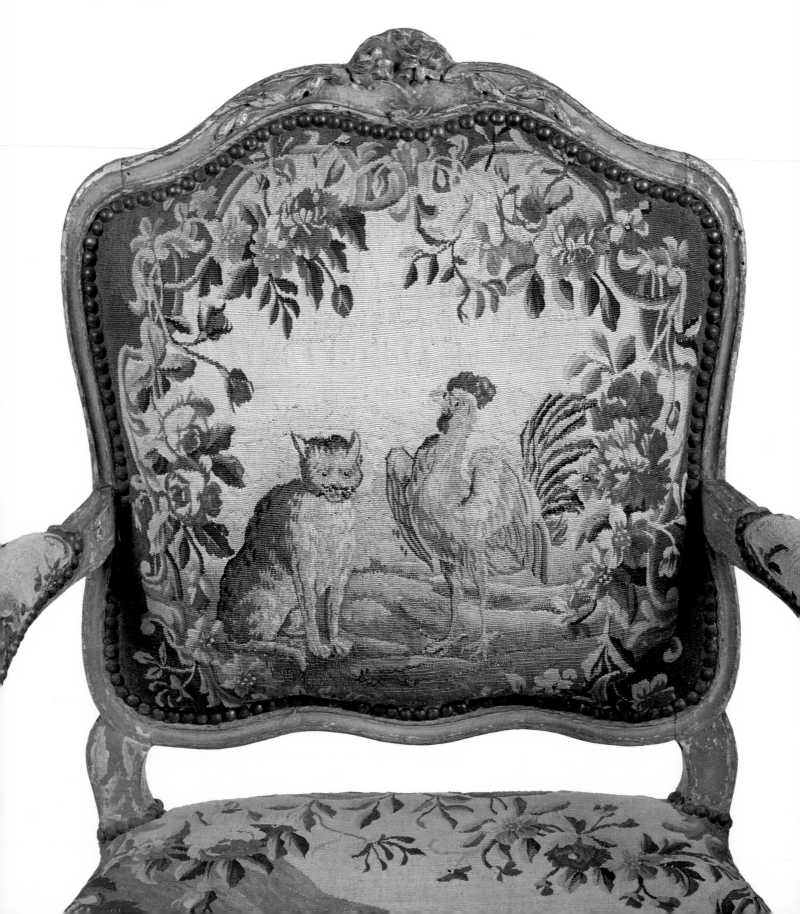

Cat-Shaped Box. This detail, from an ink and watercolor painting on silk, of a wooden box in the shape of a cat was made by Mori Sosen (Japanese, 1747–1821), an Edo period artist. The original box was not only an ornamental and useful object, but also, just as real cats can be, was likely an amusing and playful companion. The stylized floral decoration of the wooden cat has been worked around more realistic spots of black fur.

Cats figure prominently in Japanese folklore, both old and new, as benevolent beings, although there are a few horror stories about them too. One adage relates that cats with long tails will assume human form and bewitch people—a tradition that may be based on the fact that most Japanese cats are short-tailed, such as the one in the Hiroshige print (p. 82). But this cat, its long tail forming a merry spiral that matches the curling bow around its neck, is certainly not a malevolent bewitcher.

Along with all its fellows in *Metropolitan Cats,* this feline shows that cats have lent their forms, whether sleek and graceful or round and furry, to works of art and daily ornament, to objects of household and religious use, in many times and cultures throughout the world.

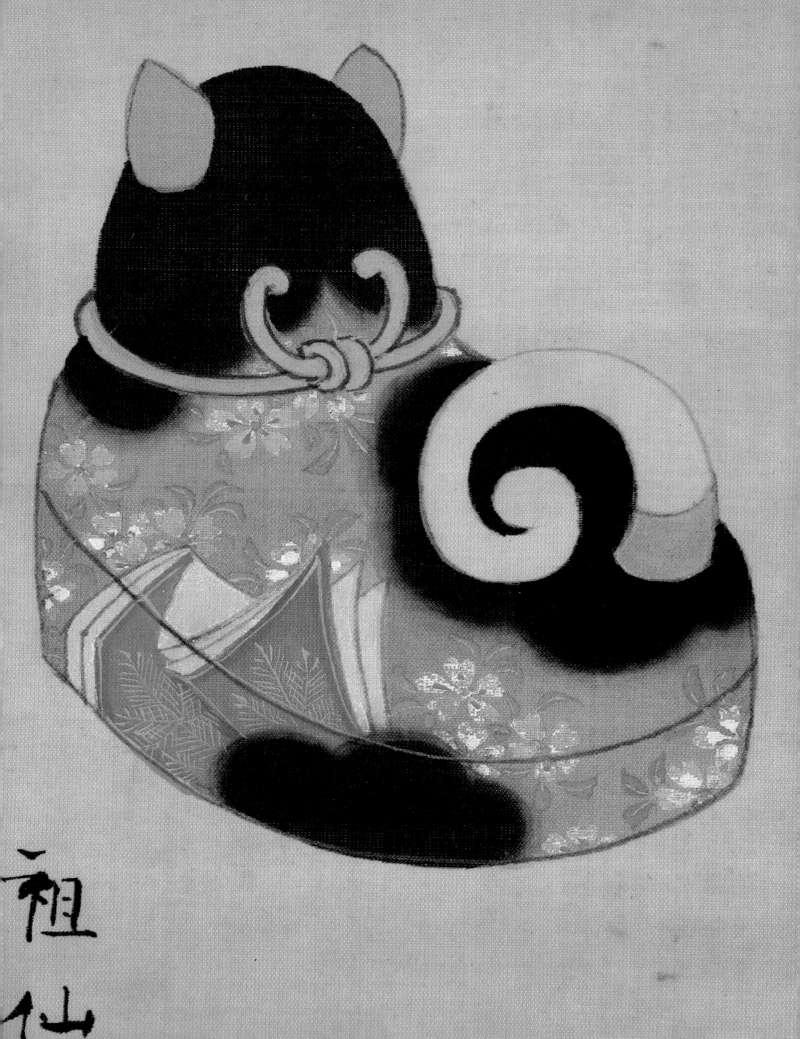

List of Illustrations

Les Chats. On a single sheet of paper, about 1867–69, Edouard Manet (French, 1832–1883) etched the cats on pages 106, 108–9.

PAGE 23. *Domestic Scene*
Annibale Carracci (Italian, 1560–1609); early 1580s
Pen and black ink, gray wash; 12⅞ x 9¼ in.
Purchase, Mrs. Vincent Astor and Mrs. Charles S. Payson Gifts and
 Harris Brisbane Dick and Rogers Funds, 1972.133.2

PAGES 24–25. *Ipuy and His Wife*
Copy of wall painting after unknown artist (Egyptian, XIX Dynasty,
 reign of Ramesses II); c. 1275 B.C.
Restored copy in tempera by N. deG. Davies, 1920–21; 18¾ x 29 in.
The Metropolitan Museum of Art, Egyptian Expedition, 30.4.114

PAGES 26, 27. *Joseph in Prison*
Master of the Story of Joseph (Flemish, active c. 1500)
Tempera and oil on wood; diam. 61½ in.
Harris Brisbane Dick Fund, 1953, 53.168

PAGES 28–29. *The Young Mother*
Nicolaes Maes (Dutch, 1634–1693)
Pen and brown ink, brown wash; 5⅜ x 7 in.
Rogers Fund, 1947, 47.127.3

PAGE 30. *Dog and Cat*
Thomas Bewick (English, 1753–1828); from *Bewick's Select Fables,*
 1878
Wood engraving; 1⅞ x 2⅜ in.
Museum Accession, 1921, 21.36.120

PAGE 31. *Compagnie Française des Chocolats et des Thès*
Théophile-Alexandre Steinlen (French, 1859–1923); 1899
Color lithograph poster; 30 x 40 in.
Gift of Bessie Potter Vonnoh, 1941, 41.12.19

PAGES 32, 33. *Harem Scene at Court of Shah Jahan*
Unknown artist (Indian, second quarter 17th century); Mughal period
Album leaf, ink, colors, and gold on paper; entire sheet 13⅛ x 8¼ in.
Theodore M. Davis Collection, Bequest of Theodore M. Davis, 1915,
 30.95.174, no. 26

PAGES 34–35. *Kiesler and Wife*
Will Barnet (American, b. 1911); 1963–65
Oil on canvas; 48 x 71½ in.
Purchase, Roy R. and Marie S. Neuberger Foundation, Inc. Gift and
 George A. Hearn Fund, 1966, 66.66

PAGE 36. *Mughal Virgin and Child*
Unknown artist (Indian, 17th century); Mughal period
Brush drawing, black and colored inks and gilt on paper; entire sheet,
 9⅝ x 5⅞ in.
Rogers Fund, 1970, 1970. 217

PAGE 37. *Man with the Plague*
Unknown artist (Italian, 15th century); from *Fasciolo di Medicina* by
 Johannes de Ketham, Venice, 1493/94
Woodcut; 12 x 8¼ in.
Harris Brisbane Dick Fund, 1938, 38.52

PAGES 38–39. *Just Moved*
Henry Mosler (American, 1841–1920); 1870
Oil on canvas; 29 x 36½ in.
Arthur Hoppock Hearn Fund, 1962, 62.80

PAGES 40–41. *Bas-de-page*
Style of Jean Pucelle (French, fl. c. 1324–1327); from *Psalter and Prayer
 Book of Bonne of Luxembourg,* c. 1345
Illuminated manuscript, grisaille and colors on vellum; 5 x 3⅝ in.
The Cloisters Collection, 1969, 69.86

PAGES 42, 43. *Emma Homan*
John Bradley (American, active 1832–1847); 1843/44
Oil on canvas; 33⅞ x 27⅛ in.
Gift of Edgar William and Bernice Chrysler Garbisch, 1966, 66.242.23

PAGE 44. *Young Woman with Cat*
Pierre Auguste Renoir (French, 1841–1919); c. 1880–82
Oil on canvas; 38¾ x 32¼ in.
Private Collection, New York

PAGE 45. *Le Chat et les Fleurs*
Edouard Manet (French, 1832–1883); from *Les Chats* by Champfleury,
 Paris, 1870
Engraving; 7⅞ x 5⅜ in.
Harris Brisbane Dick Fund, 1928, 28.93.1

PAGE 46. *Girl Making a Garland*
Hans Süss von Kulmbach (German, c. 1480–1521/22); c. 1508
Tempera and oil on wood; 7 x 5½ in.
Gift of J. Pierpont Morgan, 1917, 17.190.21

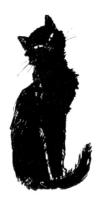

Cat and Boy. Théophile-Alexandre Steinlen (1859–1923) made this
linocut for *Des Chats: Images sans Paroles* (Paris, n.d.).

PAGE 47. *Mother, Child, and Cat*
Unknown designer of the Wiener Werkstätte, Austrian, founded 1905
Color lithograph postcard; 5½ x 3½ in.
Museum Accession

PAGES 48–49. *The Ark*
Unknown artist (Dutch, late 17th century)
Oil on canvas; 46¼ x 61¼ in.
Gift of James De Lancey Verplanck and John Bayard Rodgers Verplanck,
 1939, 39.184.20

PAGES 50, 51. *Lady with Her Pets*
Rufus Hathaway (American, 1770?–1822); 1790
Oil on canvas; 34½ x 32 in.
Gift of Edgar William and Bernice Chrysler Garbisch, 1963, 63.201.1

PAGE 52. *Self-Portrait with the Bust of Homer*
John Kay (Scottish, 1742–1826); 1786
Etching, clipped impression; 4⅜ x 3⅞ in.
Harris Brisbane Dick Fund, 1917, 17.3.756.2219

PAGE 53. *Amelia C. Van Buren and Cat*
Thomas Eakins (American, 1844–1916); c. 1891
Platinum print photograph; 8½ x 6¾ in.
David Hunter McAlpin Fund, 1943, 43.87.16

PAGE 54. *The Little Pets,* detail
Currier & Ives, publishers, American, 1857–1907
Hand-colored lithograph; 12 x 9 in.
Bequest of Adele S. Colgate, 1962, 63.550.333

PAGE 55. *Martha Bartlett with Her Kitten*
Unknown artist (American, second quarter 19th century)
Oil on canvas; 30¾ x 24 in.
Bequest of Edgar William and Bernice Chrysler Garbisch, 1979,
 1980.341.11

PAGES 56–57. *The Alling Children*
Oliver Tarbell Eddy (American, 1799–1868)
Oil on canvas; 47⅛ x 62⅞ in.
Gift of Edgar William and Bernice Chrysler Garbisch, 1966, 66.242.21

PAGE 58. *Harper's May*
Edward Penfield (American, 1866–1925); 1896
Color lithograph poster; 20 x 14 in.
Museum Accession, 1957, 57.627.9(37)

PAGE 59. *May Belfort*
Henri de Toulouse-Lautrec (French, 1864–1901)
Color lithograph poster; 31¼ x 24¼ in.
Gift of Bessie Potter Vonnoh, 1941, 41.12.1

PAGE 60. *Miss Kitty Dressing*
Thomas Watson (English, 1750?–1781) after Joseph Wright of Derby
 (English, 1734–1797); 1781
Mezzotint; 16¼ x 13 in.
Harris Brisbane Dick Fund, 1952, 53. 600.558

PAGE 61. *Said the Cat*
Charles Henry Bennett (English, 1829–1867); from *The Sorrowful End-
 ing of Noodledoo, with the Fortunes and Fate of Her Neighbours and
 Friends,* London, 1865
Hand-colored commercial printing; 8 x 6½ in.
Rogers Fund, 1906; Thomas J. Watson Library

PAGES 62–63. *My Little White Kitties into Mischief*
Currier & Ives, publishers, American, 1857–1907
Hand-colored lithograph; 8¼ x 12½ in. with border
Bequest of Adele S. Colgate, 1962, 63.550.479

PAGES 64–65. *Two Cats*
Karl Schmidt- Rottluff (German, 1884–1976)
Woodcut; 15½ x 19⅜ in.
Harris Brisbane Dick Fund, 1924, 24.11.10

PAGE 65. *Two Cats*
Félix Vallotton (French, 1865–1925); from *Pan,* 1895
Woodcut; 2½ x 2½ in.
Rogers Fund, 1943; Thomas J. Watson Library

PAGES 66–67. *Harper's July*
Edward Penfield (American, 1866–1925); 1898
Color lithograph poster; 14 x 20 in.
Museum Accession, 1957, 57.627.9(26)

PAGES 68–69. *Cats at Play*
John Singer Sargent (American, 1856–1925)
Pencil on paper; 10 x 14½ in.
Gift of Mrs. Francis Ormond, 1950, 50.130.129

PAGES 70–71. *Pussy's Return*
Currier & Ives, publishers, American, 1857–1907
Hand-colored lithograph; 8½ x 12½ in.
Bequest of Adele S. Colgate, 1962, 63.550.314

PAGE 72. *Drôlerie*
Jean Pucelle (French, fl. c. 1324–1327); from *Book of Hours of Jeanne d'Evreux;* 1325–28
Illuminated manuscript, grisaille and colors on vellum; 3½ x 2½ in.
The Cloisters Collection, 1954, 54.1.2

PAGE 73. *Woman, Man, and Cat*
Torii Kiyohiro (Japanese, active c. 1737–1766); Edo period, c. 1755
Wood-block print, colors on paper; 17 x 11 in.
Harris Brisbane Dick Fund and Rogers Fund, 1949, Japanese Print 3089

PAGES 74, 75. *Don Manuel Osorio Manrique de Zuñiga*
Francisco José de Goya y Lucientes (Spanish, 1746–1828); c. 1786–89
Oil on canvas; 50 x 40 in.
The Jules Bache Collection, 1949, 49.7.41

PAGES 76–77. *The Lacemaker*
Bernard Keil (Danish, 1624–1687); after 1660
Oil on canvas; 28½ x 38¼ in.
Bequest of Edward Fowles, 1971, 71.115.2

PAGES 78–79. *The Cock, the Cat, and the Little Rat*
J. J. Grandville, or Jean Ignace Isidore Gérard (French, 1803–1847); from *Fables de Fontaine,* vol. I, by Jean de La Fontaine, Paris, 1839
Wood engraving; 3¼ x 4⅛ in.
Museum Accession, 1921, 21.36.35

PAGE 79. *El Sueño de la Razón Produce Monstruos ("The Sleep of Reason Breeds Monsters")*
Francisco José de Goya y Lucientes (Spanish, 1746–1828); from *Los Caprichos,* 1799
Etching with aquatint; 7 x 4¾ in.
Gift of M. Knoedler & Co., 1918, 18.64.(43)

PAGES 80–81. *The Silver Tureen*
Jean-Baptiste Siméon Chardin (French, 1699–1779); 1727–28
Oil on canvas; 30 x 42½ in.
Fletcher Fund, 1959, 59.9

PAGE 82. *Cat in Window*
Andō Hiroshige (Japanese, 1797–1858); from *Famous Sights of Edo: One Hundred Views*
Wood-block print, colors on paper; 13⅛ x 8¾ in. (margins trimmed)
Rogers Fund, 1914, Japanese Print 60

PAGE 83. *Little Gray Cat*
Elizabeth Norton (American, 1887–?)
Printed color woodcut; 5⅛ x 4⅜ in.
Gift of Elizabeth Norton, 1928, 28.63.1

PAGE 83. *The Watchful Cat*
John Alonzo Williams (American, 1869–1947)
Watercolor on cardboard; 12¼ x 17⅜ in.
Gift of A. J. Hammerslough, 1940, 40.17

PAGES 84–85. *Spring Play in a T'ang Garden,* detail
Style of Hsüan-tsung (Chinese, 1398–1435); 18th century
Hand scroll, colors on silk; 14¾ x 104 in.
Fletcher Fund, 1947, 47.18.9

PAGE 86. *Von Eebruch ("Of Adultery")*
Unknown artist (German, 15th–16th century); from *Das Narrenschiff ("The Ship of Fools")* by Sebastian Brant, Basel, 1494
Woodcut; 7⅞ x 5⅝ in.
Harris Brisbane Dick Fund, 1930, 30.71

PAGE 87. *Cat and Spider*
Toko (Japanese); Meiji period (1868–1911)
Painting on silk; 14¾ x 11 in.
Charles Stewart Smith Collection, Gift of Mrs. Charles Stewart Smith, Charles Stewart Smith, Jr. and Howard Caswell Smith, in memory of Charles Stewart Smith, 1914, 14.76.61.73

PAGE 88. *The Cat and Cock*
Francis Barlow (English, 1626?–1702); from *Aesop's Fables with His Life,* London, 1687
Etching and engraving; 12¼ x 7⅞ in.
Gift of Estate of Marie L. Russell, 1946, 46.117.12

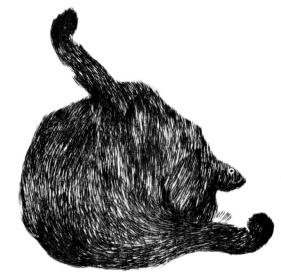

PAGES 88–89. *A Cat and a Cock*
Alexander Calder (American, 1898–1976); from *Fables of Aesop
 According to Sir Roger L'Estrange,* 1931
Linocut; 4⅛ x 5¼ in.
Gift of Monroe Wheeler, 1949, 49.89

PAGES 90–91. *Cat and Serpent*
Facsimile of wall painting by unknown artist (Egyptian, XIX Dynasty);
 c. 1300 B.C.
Copy in tempera by C. K. Wilkinson, 1920–21; 35 x 19 in.
The Metropolitan Museum of Art, Egyptian Expedition, 30.4.1

PAGE 92. *Puss in Boots*
Gustave Doré (French, 1832–1883); from *Les Contes de Perrault* by
 Charles Perrault, Paris, 1899
Wood engraving; 9⅝ x 7⅝ in.
Gift of Mrs. John Fiske, 1960, 60.714

PAGE 93. *Cat and Fishbowl*
Théophile-Alexandre Steinlen (French, 1859–1923); from *Des Chats:
 Images sans Paroles,* Paris, n. d.
Linocut; 3½ x 3¾ in.
Gift of Mrs. Edward C. Möen, 1961, 61.687.12

PAGE 94. *Cat and Yellow Butterfly*
Hsü Pei-hung, or Ju Péon (Chinese, 1895–1953)
Hanging scroll, ink and color on paper; 44 x 21¼ in.
Rogers Fund, 1956, 56.129.2

PAGE 95. *Cat and Frog*
Kawanabe Gyōsai (Japanese, 1831–1889)
Painting on silk; 14⅛ x 10⅝ in.
Charles Stewart Smith Collection, Gift of Mrs. Charles Stewart Smith,
 Charles Stewart Smith, Jr. and Howard Caswell Smith, in memory of
 Charles Stewart Smith, 1914, 14.76.61–20

PAGES 96–97. *Ceramic Cat*
Anonymous modeler (English, 17th century)
Tin-enameled earthenware; 4¼ x 5⅜ in.
Gift of Mrs. Russell S. Carter, 1945, 45.12.5

Puss in Boots. Gustave Doré's hero strikes a courtly pose below in
a detail of an engraving from *Les Contes de Perrault* (Paris, 1899).

PAGE 97. *Inrō with Netsuke*
Sekigawa Katsunobu (Japanese, mid-19th century)
Lacquer ware; *inrō:* 2½ x 2⅝ x ⅞ in.
Charles A. Greenfield Collection, New York

PAGE 97. *Dutch Tile*
Unknown artist (Dutch, 17th century); c. 1650–1700
Tin-enameled earthenware; 5 x 5 in.
Gift of W. R. Valentiner, 1908, 08.196.194

PAGE 98. *Manchu Cat*
Unknown artist (Chinese, c. 1821–1850); Ch'ing dynasty
Theater curtain, wool flannel, silk, metal; 10 ft. 8¾ in. x 6 ft. 8 in.
Gift of Fong Chow, 1959, 59.190

PAGE 99. *Cat from the Caswell Carpet*
Zeruah Higley Guernsey Caswell (American, 19th century); 1832–35
Embroidered in colored woolen yarns on twill-weave woolen fabric; de-
 tail of carpet, 13 ft. 4 in. x 12 ft. 3 in.
Gift of Katherine Keyes, in memory of her father, Homer Eaton Keyes,
 1938, 38.157

PAGE 100. *Egyptian Cat*
Unknown artist (Egyptian, Late Dynastic period, 950–350 B.C.)
Statue, hollow-cast bronze; 4¾ x 3 in.
Fletcher Fund 1966 and The Guide Foundation Inc. Gift 1966, 66.99.145

PAGE 101. *Ceramic Cat*
Anonymous modeler (English, 18th century); Staffordshire, c. 1745
Salt-glazed stoneware, agateware; H. 4½ in.
The Helen and Carleton Macy Collection, Gift of Carleton Macy, 1934,
 34.165.20

PAGE 101. *Ceramic Cat*
Anonymous modeler (English, 18th century); Staffordshire, 1750
Earthenware, tortoiseshell glaze (mottled lead glaze); H. 5¼ in.
Gift of Mrs. Russell S. Carter, 1944, 44.39.45

PAGE 102. *The Cock, the Cat, and the Little Rat*
Unknown artist after Jean Baptiste Oudry (French, mid-18th century);
 from upholstery of armchair, Aubusson, Louis XV period, 1750–75
Tapestry, wool and silk; 37⅞ x 29¼ in.
Bequest of Catherine D. Wentworth, 1948, 48.187.712

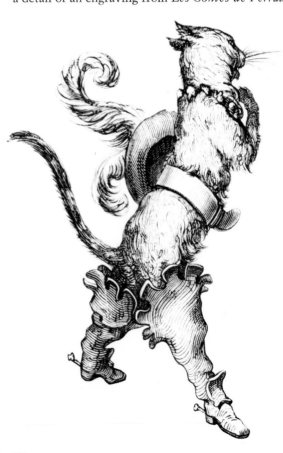

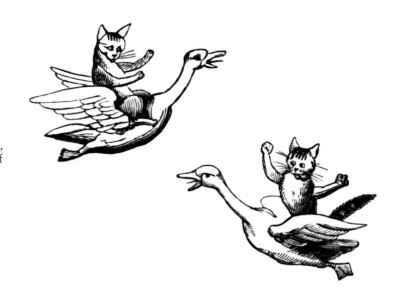

PAGE 103. *Lacquer Writing Box*
Unknown artist (Japanese, early 19th century), perhaps Gyūhōsei
Lacquer ware; 8⅜ x 10¾ x 4⅝ in.
Charles A. Greenfield Collection, New York

PAGE 105. *Cat-Shaped Box*
Mori Sosen (Japanese, 1747–1821); detail from *Monkey and Box,* Edo
 period
Ink and watercolor painting on silk; 26⅞ x 3⅜ in.
Charles Stewart Smith Collection, Gift of Mrs. Charles Stewart Smith,
 Charles Stewart Smith, Jr. and Howard Caswell Smith, in memory of
 Charles Stewart Smith, 1914, 14.76.17

PAGES 106, 108, 109. *Les Chats*
Edouard Manet (French, 1832–1883); c. 1867–69
Etching on blue paper; 7 x 8⅝ in.
Rogers Fund, 1921, 21.76.26

PAGE 107. *Boy and Cat*
Théophile-Alexandre Steinlen (French, 1859–1923); from *Des Chats:
 Images sans Paroles,* Paris, n. d.
Linocut; 3¼ x 3 in.
Gift of Mrs. Edward C. Möen, 1961, 61.687.12

PAGE 110. *Puss in Boots,* detail
Gustave Doré (French, 1832–1883); from *Les Contes de Perrault* by
 Charles Perrault, Paris, 1899
Wood engraving; entire illustration 7¾ x 9¾ in.
Gift of Mrs. John Fiske, 1960, 60.714

PAGE 111, ABOVE. *Cats Riding Geese,* details
Unknown artist after Kate Greenaway (English, 1846–1901); from
 Dame Wiggins of Lee and Her Seven Wonderful Cats, London, 1885
Woodcut; entire sheet 5¼ x 3½ in.
Museum Accession, 1921, 21.36.97

PAGE 111, BELOW. *Cat Designs*
Attributed to Ranzan (Arashiyana) Tsuneyuki (Japanese, 19th century);
 from *Chosen Gwafu,* an album compiled of designs for metal carving,
 1857
Pen and ink; entire sheet 9 x 6½ in.
The Howard Mansfield Collection, Gift of Howard Mansfield, 1936,
 36.120.699

PAGE 112. *Domestic Cat*
Thomas Bewick (English, 1753–1828); from *A General History of Quad-
 rupeds,* Newcastle-on-Tyne, 1807
Wood engraving; 2 x 2¾ in.
Museum Accession, 1921, 21.36.121

BACK ENDPAPER. *Spring Play in a T'ang Garden,* detail
Style of Hsüan-tsung (Chinese, 1398–1435); 18th century
Hand scroll, colors on silk; 14¾ x 104 in.
Fletcher Fund, 1947, 47.18.9

Cats Riding Geese. Two cats have taken to the air in these details of
a woodcut from *Dame Wiggins of Lee and Her Seven Wonderful
Cats ,* above.

Cat Designs. The three cats below, from a Japanese album of 1857,
were drawn as models for carving on knives, sword guards, and
other sword ornaments.

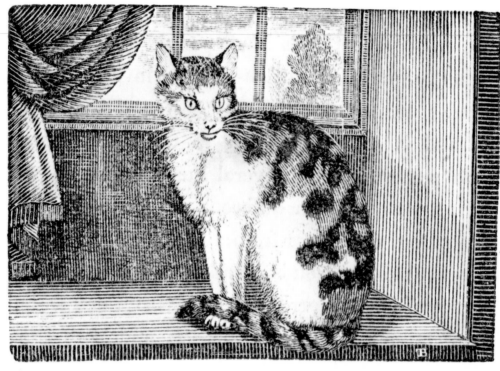

The Domestic Cat. The entries in *A General History of Quadrupeds,* published in 1807 in
Newcastle-on-Tyne by Thomas Bewick (English, 1753–1828), included wood
engravings conceived and executed in the pastoral and didactic mode. This
is Bewick's engraving of the English house cat. Although only four types
of cats were described, as opposed to thirty-six different types of dogs,
cats were beloved members of households at this time, as they
are today. The eighteenth-century poet Christopher Smart
immortalized his pet in *Jubilate Agno:* "For I will
consider my cat Jeoffrey./For he is the servant
of the Living God duly and daily serving
him./For at the first glance of the
glory of God in the East he
worships in his way."

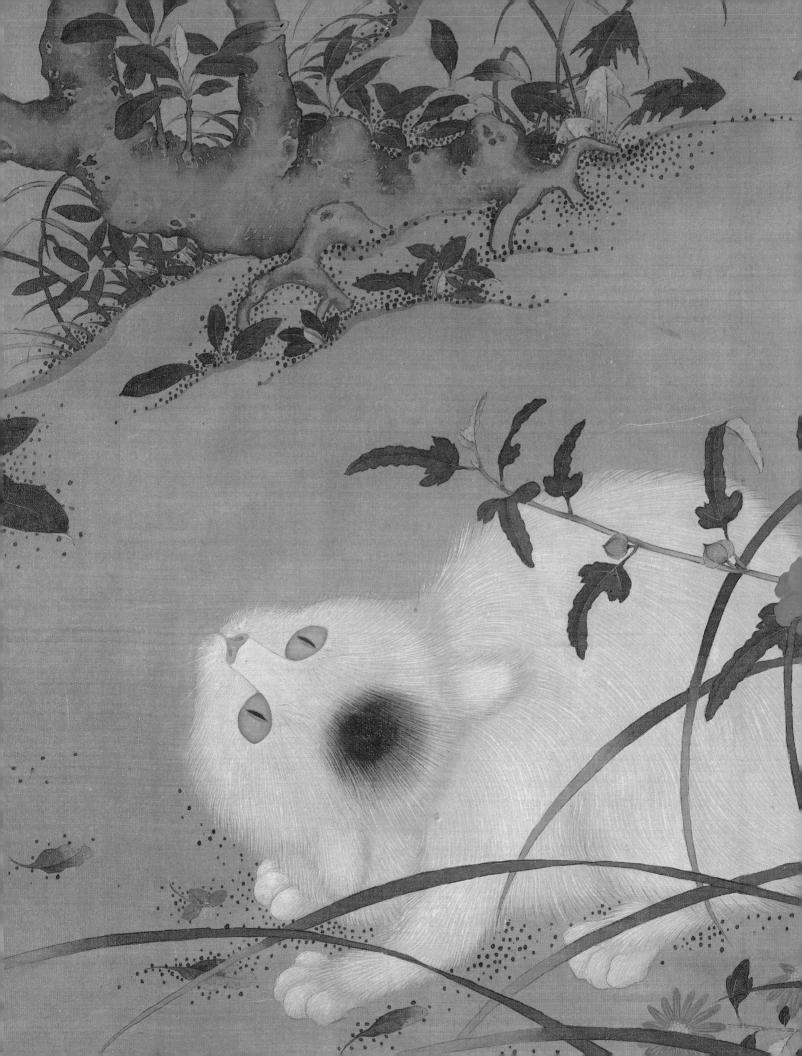